CowParade® Harrisburg:
Celebrating the Heart of Pennsylvania

CowParade Holdings Corporation

ORANGE FRAZER PRESS
Wilmington, Ohio

Copyright 2004 by CowParade Holdings Corporation
ISBN 1-882203-41-0

Text: Ronald A. Fox and Christine O'Leary-Rockey
Cow photography: Rick Christoff
Additional photography: Brian Gill
Front cover cow: *Tumbling Blocks* by Marlin E. Bert
Back cover cow: *Lil' Mookins* by Wayne Fettro
Cow silhouettes: Eileen Hasson, The Computer Company
Book and cover design: Tim Fauley, Orange Frazer Press
Art direction: Marcy Hawley, Orange Frazer Press

Visit the CowParade website at www.cowparade.com

Whitaker Center for Science and the Arts
222 Market Street
Harrisburg, PA 17101
Phone 717-221-8201
www.whitakercenter.org

The official registration and financial information of Whitaker Center for
Science and the Arts may be obtained from the Pennsylvania Department of
State by calling toll free, within Pennsylvania,
1-800-732-0999. Registration does not imply endorsement.

Whitaker Center for Science and the Arts is a 501(c)(3) organization.

Additional copies of *CowParade Harrisburg: Celebrating the Heart of
Pennsylvania* may be ordered directly from:
Orange Frazer Press
P.O. Box 214
Wilmington OH 45177

Telephone 1.800.852.9332 for price and shipping information
Website: www.orangefrazer.com

Library of Congress Control Number: 2004106095

Acknowledgements

HONORARY CHAIRS

The Honorable
Edward Rendell
Governor
Commonwealth of Pennsylvania

The Honorable
Stephen R. Reed
Mayor
City of Harrisburg

CO-FOUNDERS

Mary Webber Weston
Current Board Member &
Past President
Whitaker Center for
Science and the Arts

Byron G. Quann
President and CEO
Whitaker Center for
Science and the Arts

MOOVERS AND SHAKERS

Moo'ternity Ward Sponsor: G.R. Sponaugle & Sons
The Hobblers (Cow Platforms): Pennsy Supply Inc.
Official Photographer: Richard S. Christoff
Printing Services: Waveline Direct Incorporated
University Herd Moover: Bortek Industries
Communications Partner: The Partnership of Packer,
 Oesterling & Smith
Furniture Partner: IFR Furniture Rentals
Technology Partner: LAM Systems, Inc.

Local Cow Moovers:
 Harrisburg News Company
 Novinger Group
 Ken Lint and Penn State Expo
 The Rees Companies, Inc.
 Penske Truck Rentals

Gift Certificates for Art Supplies to Schools: Dick Blick
 Art Supplies
Artist Studio: Property Management Inc.
Clear Coating & Platform Fabricators: Dauphin County
 Technical School
Beverage Contributor: Wilsbach Distributors

SPECIAL THANKS TO

Board of Directors, Whitaker Center for Science
 and the Arts
CowParade Harrisburg 2004 Steering & Events &
 Sponsorship & Arts Committees
Thomas E. Philips, Chair, Steering Committee
David Overstreet & Carole Forker Gibbons,
 Co-Chairs, Events Committee
David A. Schankweiler, Chair, Arts Committee
Suzanne Yenchko, Chair, Sponsorship Committee

City of Harrisburg
 Louis D. Colon
 Daniel Leppo
 Joseph V. Link, P.E.
 Tina Manoogian-King
 Terri Martini

CowParade Holdings Corporation Staff
Steve Etter
Jerry Giardina
Sharon Hassinger
Judy Hepford
Hilton Harrisburg & Towers
Bill and Kathie Hughes
Clifford L. Jones
Ralph S. Klinepeter, Jr.
Eric S. Kunkel
Kunkel Foundation
Sister Martin & Holy Spirit Hospital
Pennsylvania State Department of General Services
First Lady, Judge Marjorie O. Rendell
Kirk R. Sponaugle
Staff of the Farm Show Complex
David Thomas
Thomas H. Troxell
Nathan Young

Whitaker Center for Science and the Arts Staff
Penny Brady and the Sales Staff
Jonathan Elias and Staff
Aylissa Kiely Tyndale and the Marketing Staff
especially Michelle Blace Anderson, Nicole
Newkam and Cynthia Pierce
Lisa Kreider and Staff especially Phil Neubaum,
James Wiley and Kevin Baum
Stephen F. Krempasky and Stage Production Staff
especially Matt Edgcomb & Aaron Replogle
CowParade Harrisburg 2004 Staff
Charles H. Armstrong
Ellen Brown
Jennifer Chornak
Allen Marshall
Melanie Santana
Emily Shaak
Jeanne Thomas

cow parade

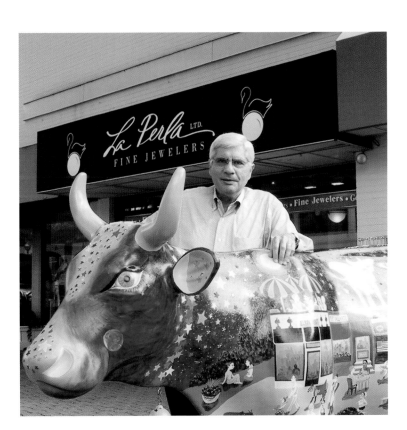

Jerry Elbaum
President, CowParade

CowParade Harrisburg 2004 was an absolute knockout. The quality of the art and the originality evidenced by the event's bovines place Harrisburg right at the top of our events. Our event partner, Whitaker Center for Science and the Arts, is to be congratulated for the proficiency of their group in organizing this exceptional public art exhibit. Many thanks are due to Boyds Bear Country™, the presenting sponsor, and the other sponsors which made this CowParade possible. We also are most appreciative of the support we received from Governor Rendell and the City of Harrisburg. The highest praise, however, must go to the participating artists.

Seeing the cows positioned on the grounds of Pennsylvania's spectacular Capitol Building has been a special treat for all of us at CowParade. We could not have selected a better venue for our 19th world event. CowParade Harrisburg 2004 will always be one of the high points of the CowParade story.

Jerry Elbaum
President, CowParade

Byron G. Quann
Whitaker Center for Science and the Arts

WHITAKER CENTER FOR SCIENCE AND THE ARTS is extremely proud to have been able to bring CowParade and all of its excitement to Central Pennsylvania. CowParade has caught the imagination of our community and has inspired pride and a sense of appreciation for the artistic talent displayed by over 120 artists who decorated a bovine.

We wish to thank our many sponsors, Choice and Prime levels, whose support made this event possible and who constantly developed new and thrilling ways to make our CowParade unique and capture even more excitement for the event. We especially appreciate the leadership and fun-loving spirit provided by Governor Ed Rendell and Mayor Stephen Reed—our Honorary Co-Chairs.

Special words of gratitude are in order for Boyds Bear Country, our Presenting Sponsor, and for Harristown Development Corporation, a Herd Sponsor; Rite Aid Corporation, Sponsor of the Cow Hospital; *The Patriot-News*, the Media Sponsor; and Waypoint Bank, the Official Bank. We also thank Pennsylvania State System of Higher Education Foundation, Inc. and Stevens & Lee PC for their support of the Cows in Schools program, a component of CowParade that assured the involvement of young artists.

We wish to thank the community and the many volunteers for their unwavering and inspirational support for this outdoor art exhibition. We are proud to stand with host cities worldwide and know that our Central Pennsylvania community hosted $136^1/_2$ cows and that over 500 artists vied to be selected to paint them.

Whitaker Center for Science and the Arts, located in downtown Harrisburg, provides important educational and cultural opportunities for the entire region. CowParade Harrisburg 2004 has been a financial success for the continuing mission of Whitaker Center. Of equal importance is that many other non-profit organizations benefited as well. Sponsors were able to direct up to 25% of the net auction price of their Cow to a charity of their choice. This event was truly community-wide.

On behalf of the Board of Directors of Whitaker Center for Science and the Arts, thank you.

Byron G. Quann
President and Chief Executive Officer
Whitaker Center for Science and the Arts

Byron G. Quann
Whitaker Center for Science and the Arts

Edward G. Rendell
Governor

Stephen R. Reed
Mayor

Edward G. Rendell
Governor, Commonwealth of Pennsylvania

Stephen R. Reed
Mayor, City of Harrisburg

ART IS FOR EVERYONE AND COWPARADE HAS a distinctive tradition of taking art out of the museums and onto the streets for everyone to enjoy. We are thrilled to welcome the world's premier public art exhibition to Pennsylvania's Capital Region, an event that puts us in the ranks of the world's most exciting cities.

Harrisburg is not only the seat of our great state's government, but a vibrant center of arts and culture enjoying its own local renaissance. In 2004, Harrisburg, Pennsylvania joins Stockholm, Sweden, Manchester, England, and Prague, Czech Republic as CowParade destinations. What a great tribute to our ability to attract artistic and financial support and create a world-class public art environment.

Presented by Boyds Bear Country, the Harrisburg herd reached 136 and a half fiberglass cows supported by over 90 community organizations and individuals who stepped up as sponsors. The caliber of the artists, the breadth of support from our community sponsors, the participation of local schools and universities, and the sheer public interest have been phenomenal. One has only to turn these pages to appreciate how the best and brightest of our artists approached their bovine canvases with remarkable humor and whimsy.

As the honorary co-chairmen of the campaign, we have been delighted to help Whitaker Center for Science and the Arts showcase the array of artistic talent in the Capital Region, which will generate endless community excitement and usher in untold economic benefits to our community.

The Harrisburg area is renowned for its seminal place in our nation's history. CowParade Harrisburg marks a new chapter in our region's history, one that will be remembered for generations to come.

Edward G. Rendell
Governor
Commonwealth of Pennsylvania

Stephen R. Reed
Mayor
City of Harrisburg

CowParade—Moo'ving Art Around The World

CowParade® HAS CAPTURED THE HEARTS and imaginations of millions of people around the world over the past four years, bringing art out of the museum and onto the streets in an 'udderly unique' way.

Featuring its famous life-size cow sculptures, CowParades have literally taken over the cities of Chicago, New York, and London, just to name a few, turning their streets, parks, and other public places into stampedes of art! Each CowParade event takes on the distinct character of the city, region and its artists; the cows are merely beautiful and fun canvases on which the artists explore their city's unique culture and history, while showing off the full extent of their creativity.

The essence of CowParade is the artistic creativity it generates and the wonderful smiles brought to the faces of children and adults alike. CowParade Chicago event organizer Peter Hanig best captured the essence of the public art movement led by CowParade:

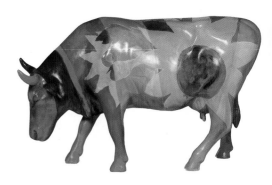

"Art is about breaking down barriers. It gets people to feel, to think, to react. So when you come across life-sized cow sculptures that have been covered in mirrors or gumdrops, Cows that have been painted with elaborate themes or transformed into something else entirely, you can't help but stop and think about what it means. All your preconceived ideas go out the window. Suddenly people see that art can be fun and that art can be interesting to everyone, not just people who frequent museums."

Featured in this book are CowParade's latest works on the streets of Harrisburg, Pennsylvania.

History of CowParade
HEADQUARTERED IN WEST HARTFORD, Connecticut, CowParade is the world's largest and premier public art event. Since Chicago in 1999, CowParade has visited 19 cities on four continents. While the basic cow sculptures remain the same,

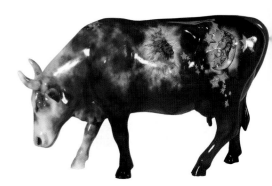

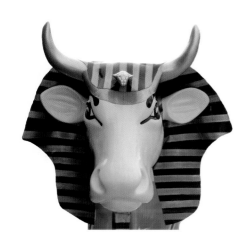

each city's artists are challenged by the creations from past events, inspired by the culture and history of their respective cities, and moved by their own interpretation of the cow as an object of, or canvas for, art.

Why Cows?

THEY ARE SIMPLY UNIQUE, three-dimensional canvases to which the artists can easily relate. There is really no other animal that can adequately substitute for the cow and produce the level of artistic accomplishment evident in the 19 CowParade events. The surface area and bone structure of the CowParade sculptures are just right, as are their heights and lengths. Each form—standing, grazing, and reclining—has unique curves and angles, making them ideally suited to all forms of art. They have now been reinterpreted, altered, and morphed into over 2500 one-of-a-kind works of art by artists worldwide.

Equally important, the cow is an animal we all love. The cow is whimsical, quirky and never threatening. She provides us with milk, is the source of heavenly ice cream, and is the inspiration for one of our first words—"mooo." From early on in life, we all have a connection with the cow in one way or another.

Who are the Artists?

COWPARADE EVENTS ARE OPEN to artists of all backgrounds and disciplines.

1999	2000	2001	2002	2002/2003	2003	2004
Chicago, IL	New York, NY Stamford, CT W. Orange, NJ	Kansas City, MO Houston , TX Sydney, Australia	London, England Venspils, Latvia Portland, OR Las Vegas, NV	San Antonio, TX Auckland, New Zealand	Atlanta, GA Brussels, Belgium Dublin, Ireland Isle of Man, UK Tokyo, Japan West Hartford, CT	Harrisburg, PA Prague, Czech Republic Stockholm, Sweden Manchester, England

Professionals and aspiring artists, painters and craftsman, and artists of all ages are invited to participate. CowParade events have attracted renowned and celebrity artists including Simon Bull, Howard Behrens, Peter Max, LeRoy Neiman, Patrick Hughes, Romero Britto, and *Sopranos* star Federico Castelluccio.

Each event begins with a "Call to Artists" inviting local and regional artists to submit designs. Parameters for the designs are set wide to encourage a broad range of art and artists. There are restrictions only against blatant advertising, political slogans, religious messages and inappropriate images. A large portfolio is created from which event sponsors select their desired artist and design. The common denominator to each event is the flood of designs that pour in as the submission deadline approaches. Sponsors' biggest challenge is picking just one design. For every official cow produced, there are ten design submissions that do not get chosen. 2500 designs were submitted for CowParade New York alone and, to date, over 10,000 artists from around the world have applied to paint a cow.

What Happens to all of those Cows?

AT THE CONCLUSION OF EACH EVENT, the cows get 'rounded up', refurbished, and sold at auction for the benefit of non-profit organizations. Premier auction houses such as Christie's, Sotheby's and Phillips Auctioneers have all conducted CowParade auctions, which have raised over $6 million thus far. The CowParade Chicago auction raised an amazing $3 million for charity, including $1.4 million from the internet auction hosted by the Chicago Tribune and $2.1 million at the live auction conducted by Sotheby's. The average bid price on the 140 cows was nearly $25,000, with the top cow, *HANDsome*, selling for $110,000. The CowParade New York live auction raised an equally impressive $1,351,000 benefiting several New York City charities. *Tiffany Cow* garnered the top bid at $60,000. Past auction purchasers include Oprah Winfrey, Ringo Starr, and Princess Firyal of Jordan. CowParade London 2002's auction drew a record 1500 attendees.

After the auctions, winning bidders bring the cows to their new homes. Cows have been spotted at ski resorts and beach homes, on farms and ranches, in backyard gardens and

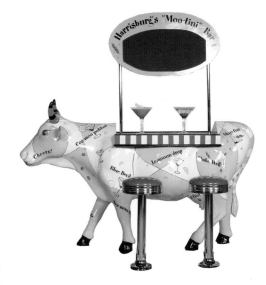

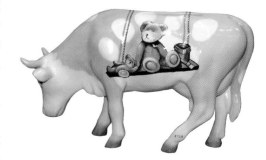

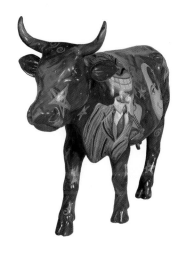

livingrooms, and even building and residential rooftops. You just never know where one of the Cows will appear.

On the Horizon…
COWPARADE TRAVELS TO THE WORLD'S most exciting cities in 2004 and 2005. On the horizon are events in Stockholm, Sweden, Manchester, England, Johannesburg, South Africa, Barcelona, Spain, and Monaco. CowParade will moo've to South America in 2005, and after that look for cows grazing in China, Russia and other unique and exotic locations around the world.

Central Pennsylvania's Moo'ving History

COWS. HERE IN CENTRAL PA we love 'em. So much, in fact, that we had a parade...a CowParade! Dozens of cows invaded our city and towns, sidewalks, and schools, dazzling us in their colorful, moo-thical ways.

It is only fitting that Harrisburg hosted a CowParade. The benevolent bovine has been the backbone of Central Pennsylvania since 1682, when the beacon of religious freedom was lit by our founder, William Penn. Penn's colony became a bastion of that freedom, a freedom that remains the mainstay of our great country today. While freedom may have been the offer, it was the rich limestone valleys and their fertile, black soil that lured many settlers to come. By the mid 1750s, Central PA had developed a prosperous and economically strong community, producing an abundance of wheat, rye, corn, and, of course, dairy!

Dairy was a daily staple for families from the beginning of our earliest settlements. One dairy cow could yield enough milk daily to produce cream for cooking, milk for drinking and butter, cottage cheese and other staples of the American diet. An entrepreneurial family would often have two or three, selling the extras to friends and neighbors in need. As Pennsylvania began to develop its growing industry, farmers would bring fresh milk and cream into town where the townsfolk would be waiting with buckets, pots and pans for their daily delivery of "white gold."

Central Pennsylvania farms were so productive that by the 1850s organized agriculture had become a mainstay of the Pennsylvanian economy, enabling the industrial revolution to explode. By simply feeding our families and strengthening our farms, Central Pennsylvania agriculture moo-raciously mooo'ved from its simple beginnings to an economic force to be reckoned, and now, the fourth most productive dairy state in the country.

A cow on every farm, a creamery in every town! That was Central Pennsylvania at the turn of the 1900s. Electricity and refrigeration had given milk production an exciting new turn as

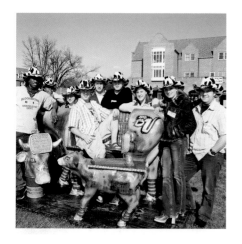

suddenly milk could be transported and stored. The Keystone State scrambled to improve its industry, turning to the Agricultural College of Pennsylvania—now known as our own Penn State University—to lead the charge. Together with the leading industrialists and expanding agricultural community, Central Pennsylvania became a leader in the production of milk, cheese, ice cream and a new delicacy: Chocolate!

Yes, chocolate! Once the sweet, creamy treat could only be had by the rich or the very lucky. But in 1902, businessman and visionary Milton S. Hershey returned to his Central Pennsylvanian childhood home to begin producing an unheard-of novelty: Affordable chocolate. Lured by the promise of its fresh, abundant supply of milk, Milton Hershey started by building a factory, but finished by creating our own Hershey! Certainly The Sweetest Place On Earth℠!

In 1917, Pennsylvania agriculture was honored for its role in the state's economy with the first annual Farm Show—a huge celebration of agriculture and its importance to our communities. The Farm Show was a great success, and was gradually expanded to last five days, bringing in thousands of people each day.

The Cows Among Us

TODAY, THE PENNSYLVANIA FARM Show is by far the largest indoor farm show event in the country. Each year, over 400,000 people flock to the Capital City to the Farm Show Complex—using over one million square feet of exposition space and bringing together thousands of local, national and international exhibitors and spectators into a monumental event.

Despite the changing times, Agriculture remains the No. 1 industry in Pennsylvania, and the Commonwealth ranks fourth in the nation for dairy production. Central Pennsylvania is home to six of the state's top dairy producing counties, including: Lancaster, Franklin, Berks, Chester, Lebanon and Cumberland Counties.

Altogether, Pennsylvania enjoys over 600,000 cows grazing in our state—almost half of which are found here, amidst the roll of the countryside and now, along side their beautiful, painted brethren. They are the heart, the soul and the backbone of Central Pennsylvania. They are its heritage and its inheritance, and one set of the many faces bringing the bovine beauty of Pennsylvania home.

Boyds Bear Country

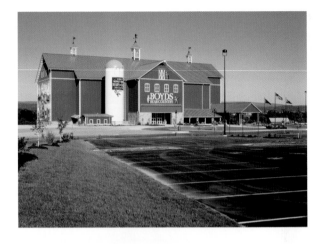

"We were delighted to be the banner sponsor of this wonderful exhibit that came to our community thanks to the efforts of the Whitaker Center," said Jan Murley, CEO of the Boyd's Collection Ltd. "Boyds Bear Country's big red barn is the perfect setting to showcase cows and introduce our guests to the many talented artists in the area. CowParade is about promoting creativity and having fun, two things that we deeply cherish at Boyds."

Known as "The World's Most Humongous Teddy Bear Store," Boyds Bear Country, the presenting sponsor of CowParade Harrisburg, opened its 120,000 square foot Boyds Bear Country Barn just south of Gettysburg in September 2002. This unique shopping experience features a spectacular world where Boyds bears and barnyard friends, including bovines, live and play. Interactive displays include a Teddy Bear Nursery where visitors can become proud parents of their very own bear cub, Digby's Super Duper Bear Factory where visitors can customize their bear's personality and accessories, Land of Libearty where the patriotic bears live along with seasonal exhibits, year-round activities, and family-friendly fun!

As the Presenting Sponsor, Boyds Bear Country hosted two major events at their location and sponsored five life-size fiberglass cows—including one "mini-moo"—including a whimsically-designed "mama, papa and baby bear" cow family.

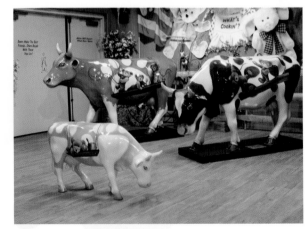

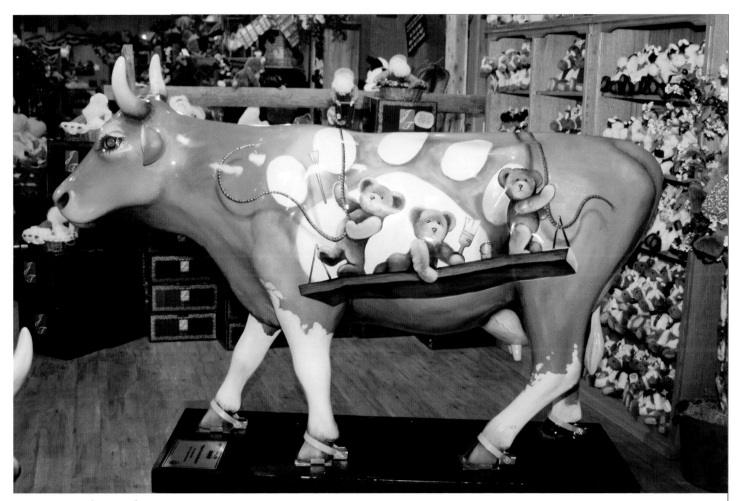

Missy Pawsides Mookins
Wayne Fettro
Boyds Bear Country

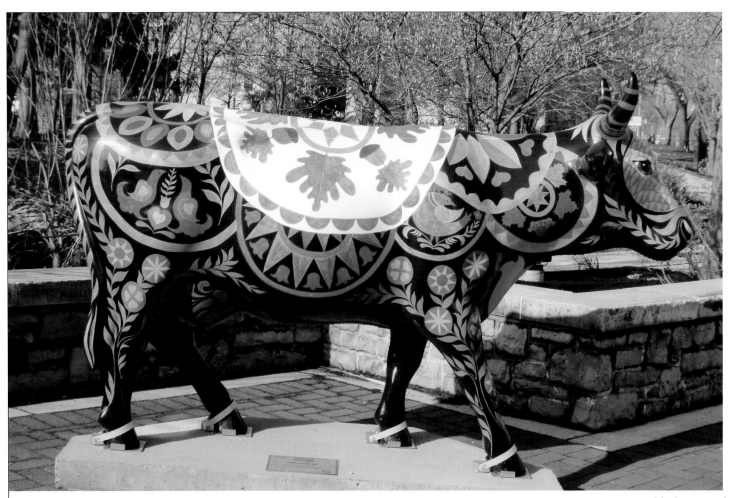

Udderly Hexed
Barbara Banco
Boyds Bear Country

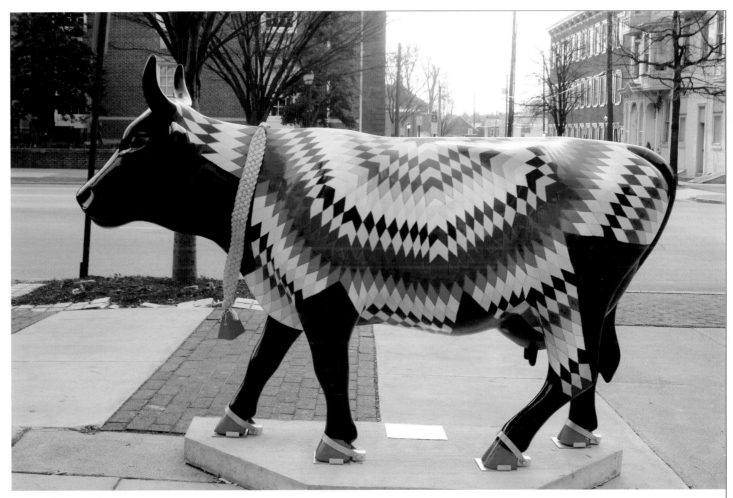

Star of Pennsylvania
Barbara E. Cramer
Boyds Bear Country

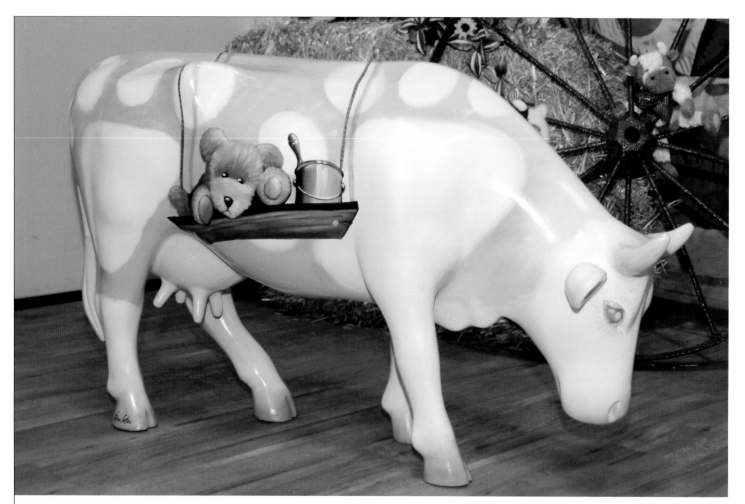

Lil' Mookins
Wayne Fettro
Boyds Bear Country

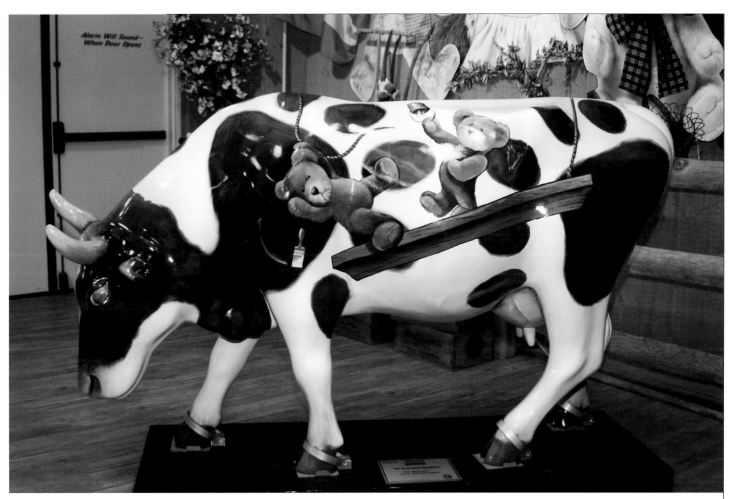

Ol' Pawsides Mookins
Wayne Fettro
Boyds Bear Country

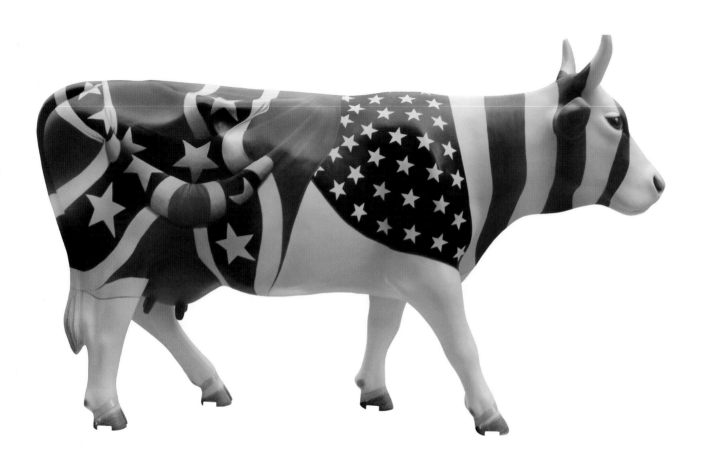

Cattle of Gettysburg
Victoria Goodhart
Boyds Bear Country

RiteAid Corporation Official Cow Hospital Sponsor

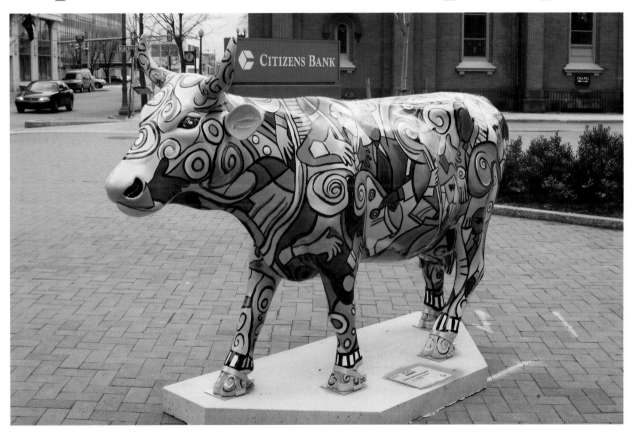

Music COW Extravaganza
Ophelia M. Chambliss
Rite Aid Corporation

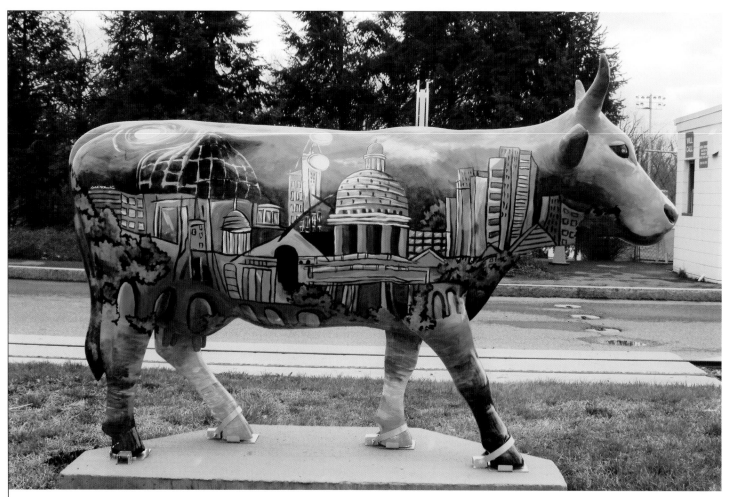

Skyliner
Ophelia M. Chambliss
Rite Aid Corporation

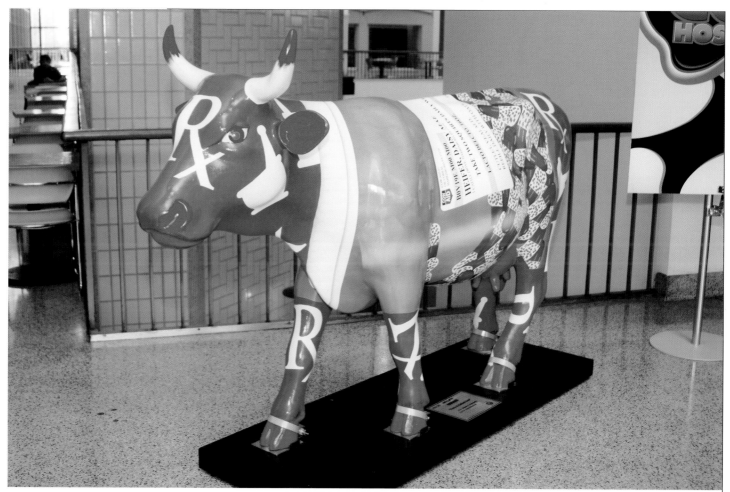

Farm-A-Suited Cow
Stephen F. Krempasky
Chain Drug Review, Racher Press, Inc.

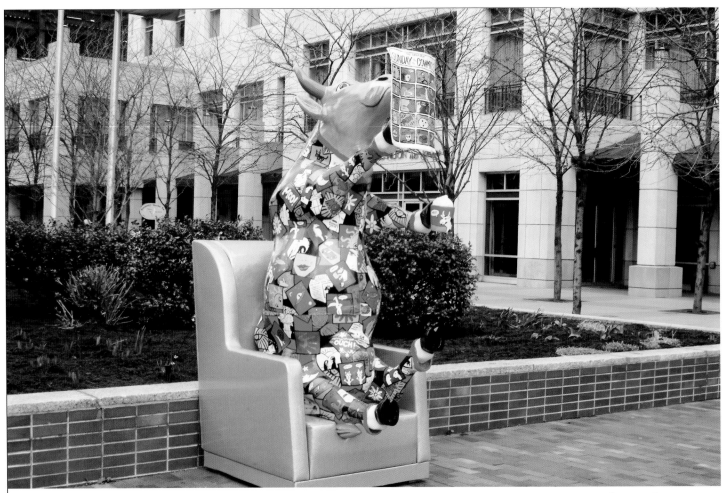

The Sunday Cowmics
Lorna E. Carlson
Rite Aid Corporation

Waypoint Bank Official Bank Sponsor

Moola Mae
Robert Stadnycki
Waypoint Bank

Mootivational Cow
Joanne P. Cassaro
Waypoint Bank

Moo Bella
Daniel Burns
Waypoint Bank

Her 1
Isaiah Zagar
Waypoint Bank

Harristown Development Corporation Herd Sponsor

Joe-Pa
Rebecca Pollard Myers
Harristown Development Corporation

Strawberry Cow
Bill Dussinger
Strawberry Square Development Corporation
Harristown Development Corporation

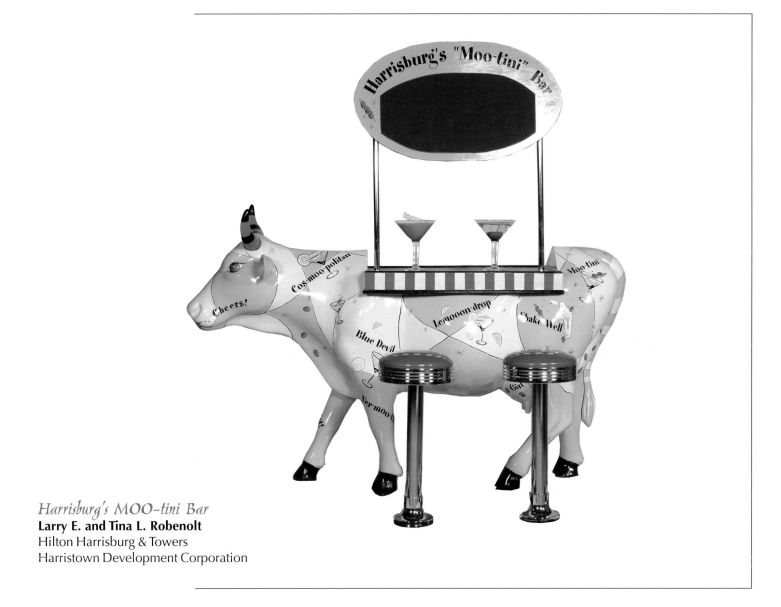

Harrisburg's MOO-tini Bar
Larry E. and Tina L. Robenolt
Hilton Harrisburg & Towers
Harristown Development Corporation

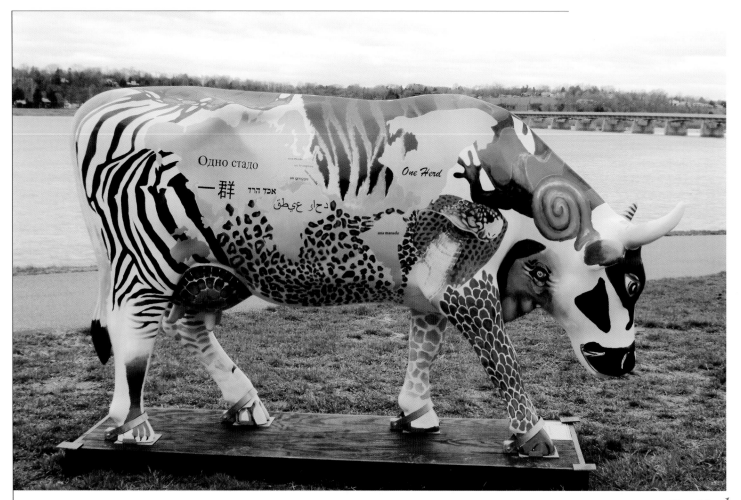

One Herd
**Edward J. Webber and Scholastic Awards Students Shaundi Billet, Asha Early,
Romeeka Gayhart, Eric Gibble, Maura Roth-Gormley, Megan Kern, Steve Kuhn, Greg Puglese and Sara Schaeffer**
The Patriot-News

The Patriot-News Official Media Sponsor

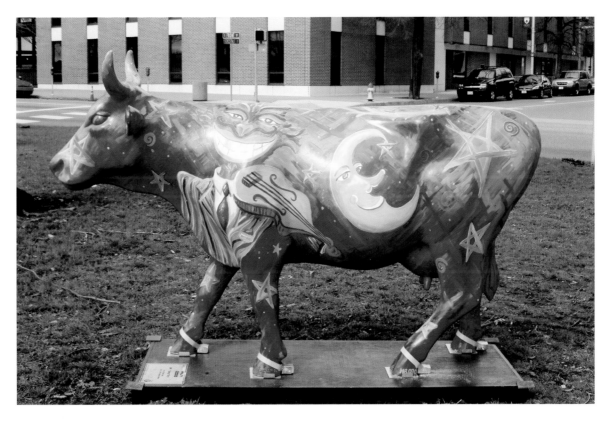

Jump This!
Chad Alan
The Patriot-News

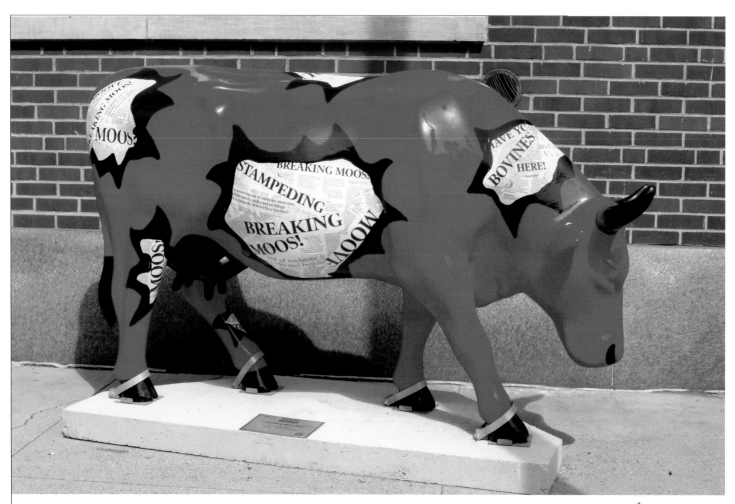

Breaking Moos Cow
Holly Blyler
The Patriot-News

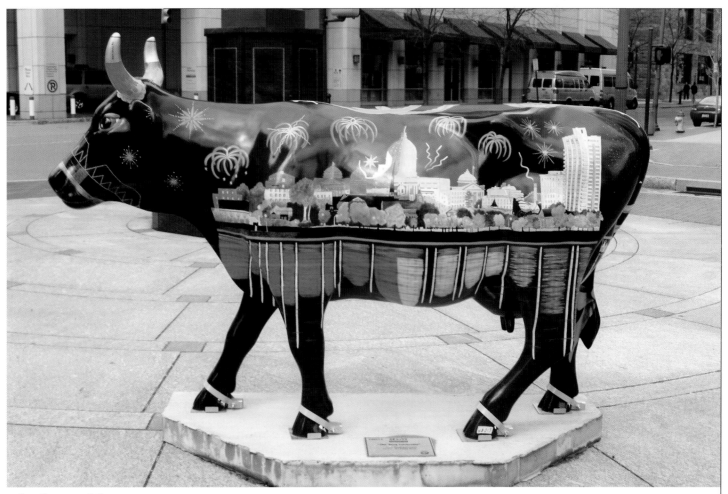

The 'burg Celebrates
Peggy Gaizauskas
The Patriot-News

Pennsylvania State System of Higher Education

EDUCAID

WACHOVIA

Public Financial Management
Financial and Investment Advisors

M&T Bank
Understanding what's important:

Annony-moos

Students at the state-owned universities in Pennsylvania had a unique opportunity to display their talents as part of CowParade Harrisburg 2004. All universities in the Pennsylvania State System of Higher Education joined forces to create a herd of 14 cows—one per university—in what was a first in CowParade history.

Student artists competed with their campus peers for the right to have their creations displayed in the world's largest public art exhibit. In addition, winning students also were awarded scholarships for their participation. A total of $24,000 in scholarships was raised with the generous support of Educaid, the student loan division of Wachovia; M&T Bank; and PFM. The Pennsylvania State System of Higher Education Foundation, Inc., the System's fundraising arm, purchased the 14 cows for the universities.

"This event has given some of our most talented students an opportunity to demonstrate their imaginative and creative artistic abilities," said State System Chancellor Judy G. Hample. "CowParade is a worldwide event. We are proud to have the State System, our universities and our students be a part of it."

Campus pride and collegial spirit overtook the universities as students prepared their cows for the big move to Harrisburg. In addition to showcasing their talented students, many of the universities used CowParade as a learning experience. For example, the students at Cheyney University of Pennsylvania used their cow "Liberty Belle" as their way to "tell the story of history, slavery and oppression to the eventual discovery of liberty."

"What better way to show our support for the art community, and to show the world what our students can do," said State System Foundation Director Nelson Swarts. "It has been a great experience for everyone involved."

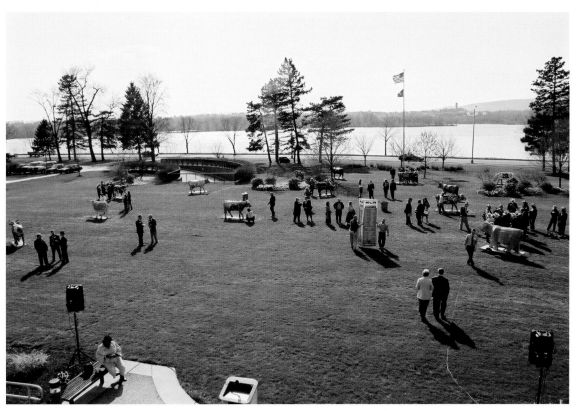

Harrisburg, Failor Green, Dixon University Center: The State System celebrates its artists and cows at an ice cream social on the lawn of the System's headquarters in Harrisburg. The campus overlooks the scenic Susquehanna River.

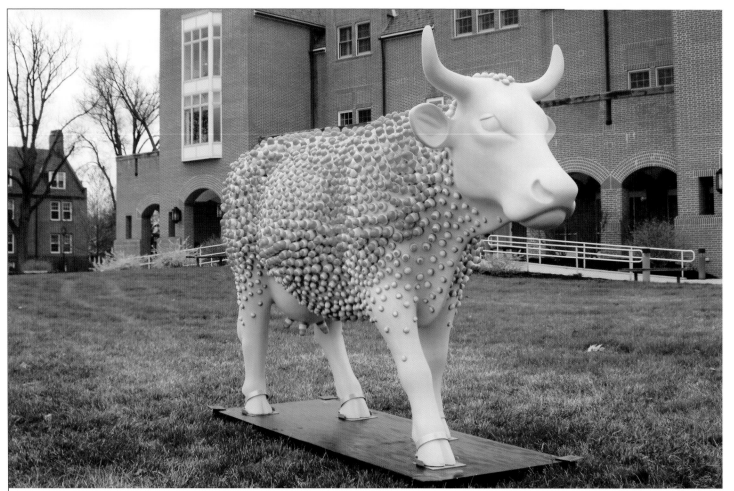

Udderly Californian
Laura DeFazio with CUP Art Students, California University of Pennsylvania
Pennsylvania State System of Higher Education Foundation, Inc.

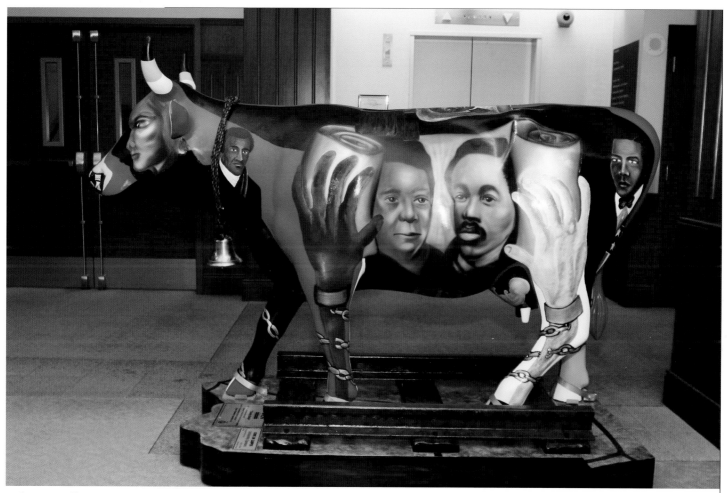

Liberty Belle
M. Dantonio-Fryer, J.T. Keener and CU Fine Arts Society, Cheyney University of Pennsylvania
Pennsylvania State System of Higher Education Foundation, Inc.

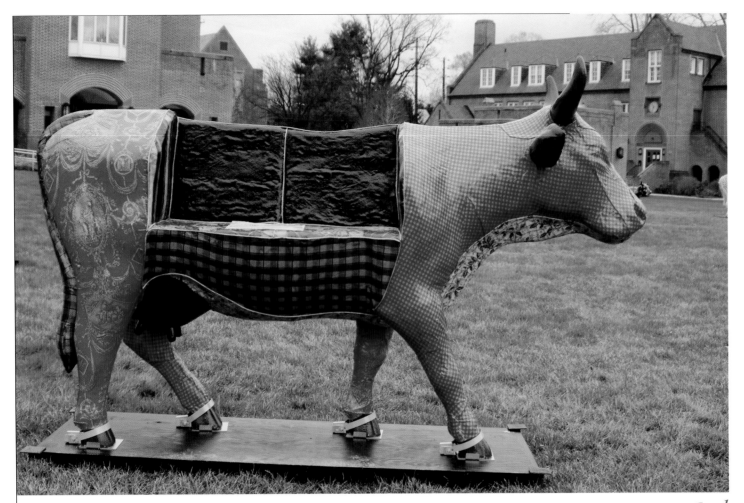

Cowch
Melanie Belinsky, Clarion University of Pennsylvania
Pennsylvania State System of Higher Education Foundation, Inc.

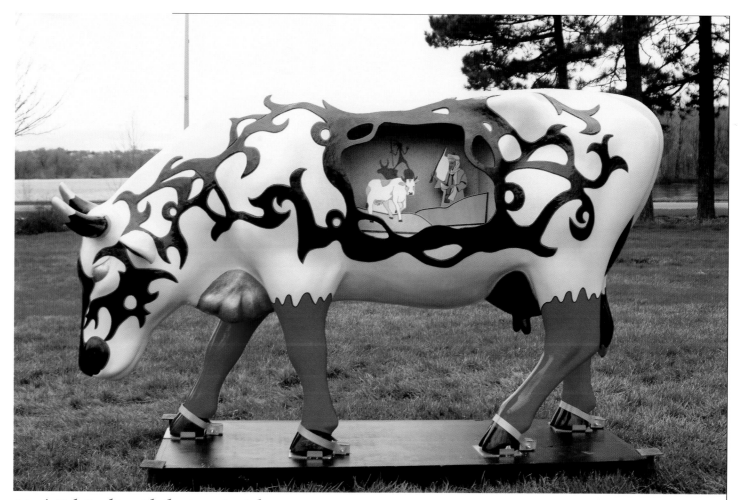

Man's Relationship with the Domesticated Cow
Thomas Hitner, West Chester University of Pennsylvania
Pennsylvania State System of Higher Education Foundation, Inc.

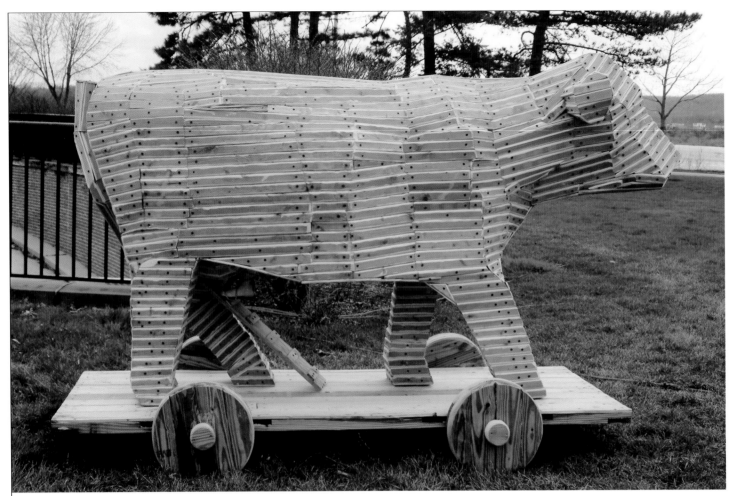

Trojan Cow
Katlyn Basilone & Brett Davis, Edinboro University of Pennsylvania
Pennsylvania State System of Higher Education Foundation, Inc.

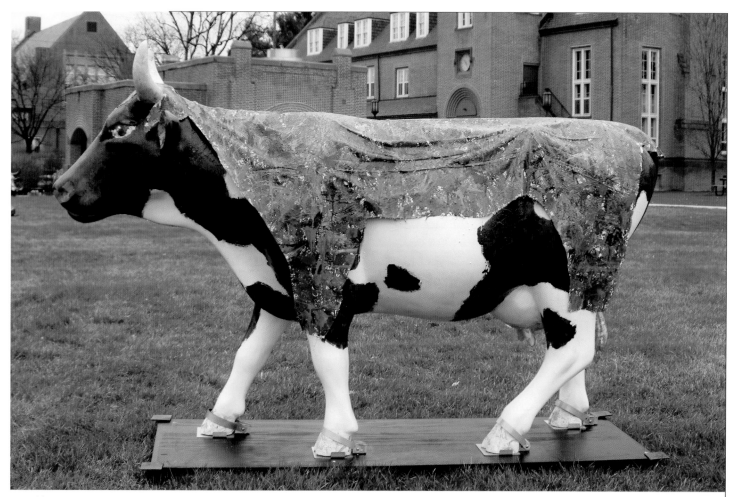

Wolf
David Lindsay, Indiana University of Pennsylvania
Pennsylvania State System of Higher Education Foundation, Inc.

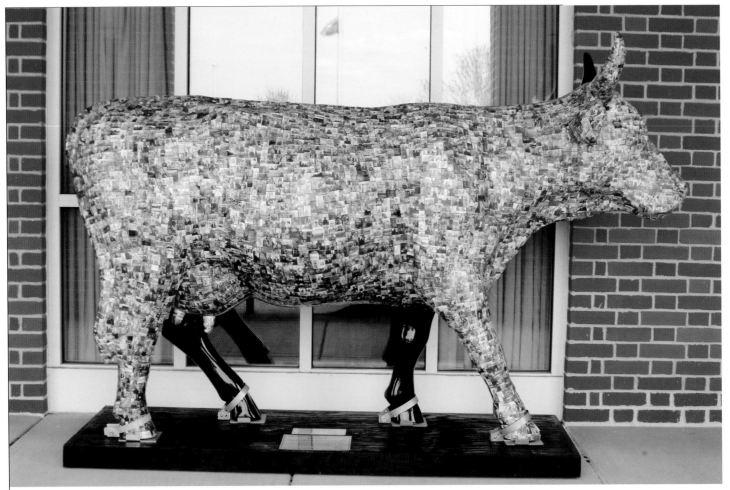

Lock Haven in Black and White

Neil C. Davis & Steven A. Beatty, Lock Haven University of Pennsylvania

Pennsylvania State System of Higher Education Foundation, Inc.

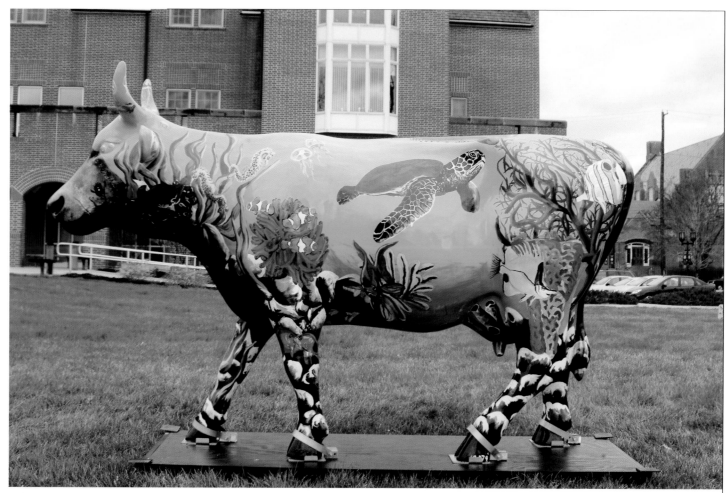

The Elusive Sea Cow
Abigail J. Krantz, Kutztown University of Pennsylvania
Pennsylvania State System of Higher Education Foundation, Inc.

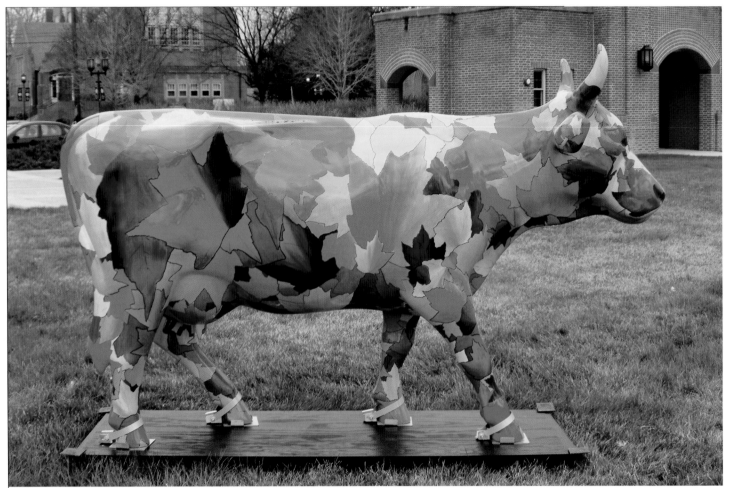

Falling Cow
Christina M. O'Neill, Millersville University of Pennsylvania
Pennsylvania State System of Higher Education Foundation, Inc.

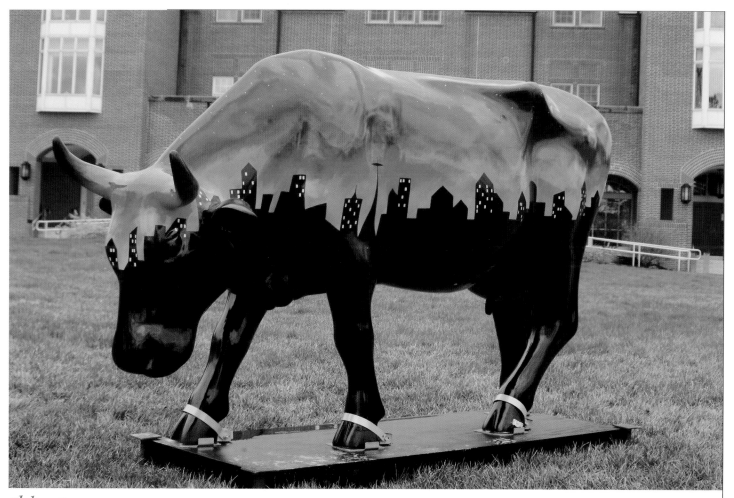

Skyline Cow
Michael S. Murray, Mansfield University of Pennsylvania
Pennsylvania State System of Higher Education Foundation, Inc.

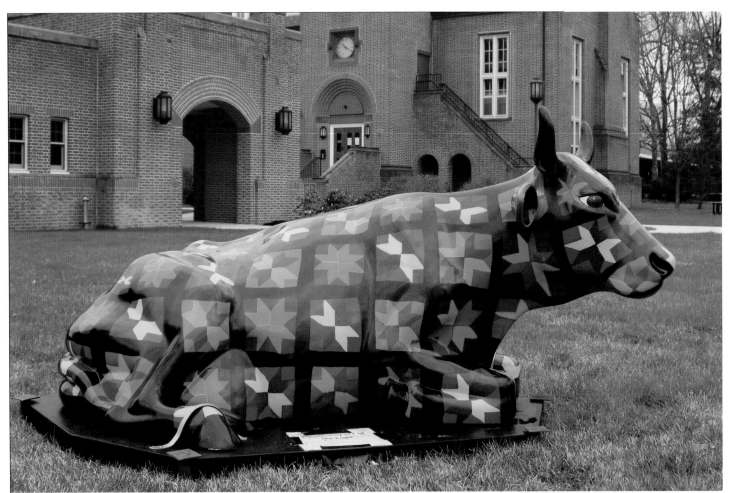

Blanketed Bovine
Margaret Dameron, Shippensburg University of Pennsylvania
Pennsylvania State System of Higher Education Foundation, Inc.

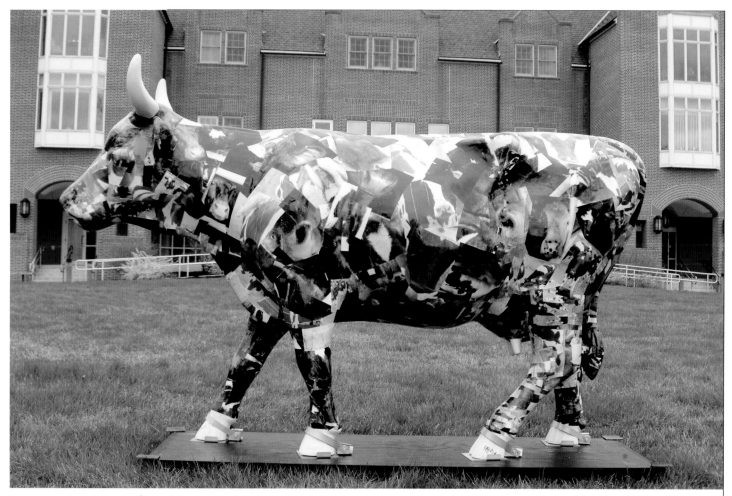

From a Cow's Point of View
Jennifer Clugsten & Nicole M. Fiedler, Slippery Rock University of Pennsylvania
Pennsylvania State System of Higher Education Foundation, Inc.

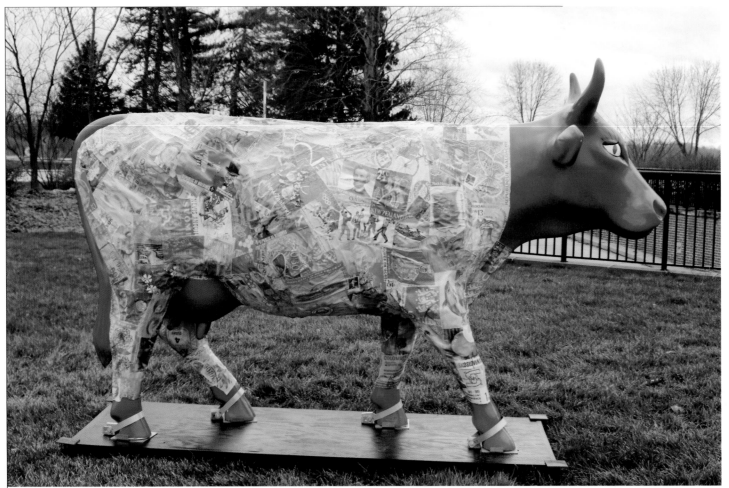

Stamp Cowlection

Nicholas R. Paust, East Stroudsburg University of Pennsylvania
Pennsylvania State System of Higher Education Foundation, Inc.

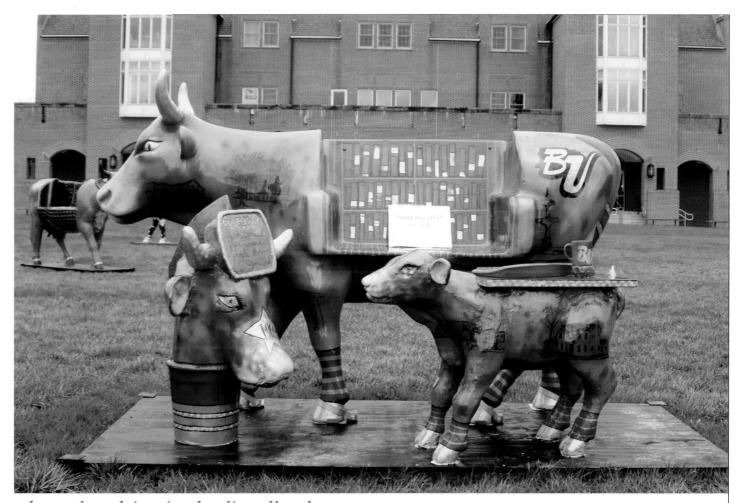

Educational Cowch for Life with Calfee Table and Cowputer

Student Art Association of Bloomsburg University, Bloomsburg University of Pennsylvania
Pennsylvania State System of Higher Education Foundation, Inc.

High School Herd

 Annony-moos

The law firm of Stevens & Lee PC, along with Whitaker Center for Science and the Arts, sponsored "The High School Herd" of cows. The High School Herd consisted of 12 cows created by Harrisburg area high school artists. A panel of judges headed by Pennsylvania's First Lady, Judge Marjorie O. Rendell, selected the participating high school winners.

$1,000 was awarded to the participating student due to the generous contributions **M&T Bank** and **Public Financial Management (PFM),** both of which provided $10,000 and a third anonymous contributor who provided $6,000 towards the awards fund.

Stevens & Lee PC provides a broad range of legal and other services to the business community in the mid-Atlantic region. From large corporations doing business internationally to emerging technology companies, their clients are varied in size and industry but share equally in the common goal of success.

M&T Bank has built its business on a tradition of reliability, accuracy and responsiveness to the needs of their customers. They believe strongly in taking an active role in the communities they serve and are proud of their long history of civic and charitable support, including the leadership and volunteer efforts of their employees.

PFM is the nation's leading financial and investment advisory firm.

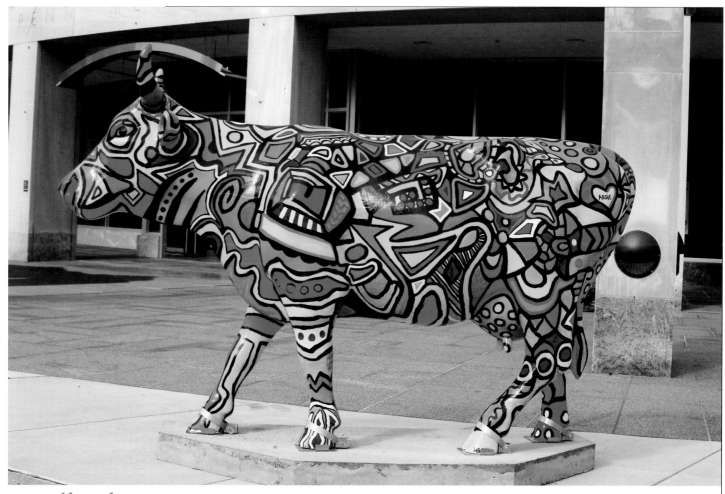

Crazy Old Wendy
Mary Logan, Mechanicsburg Area Senior High School
Stevens & Lee PC

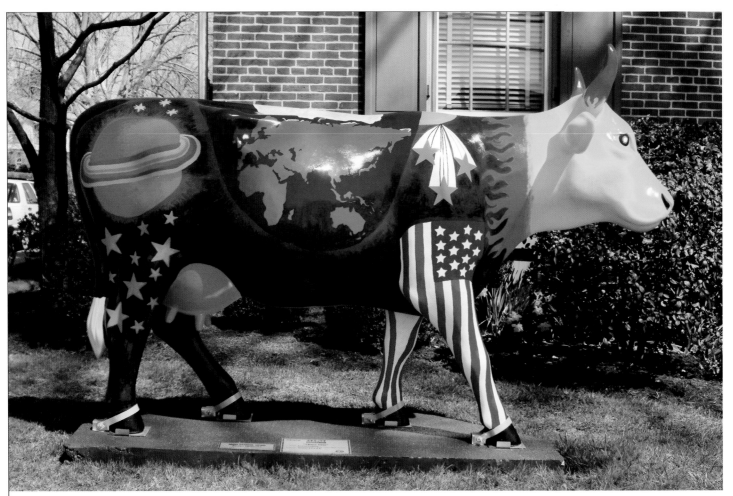

Space Cow
Andrew Cerjanic, East Pennsboro Area Senior High School
Stevens & Lee PC

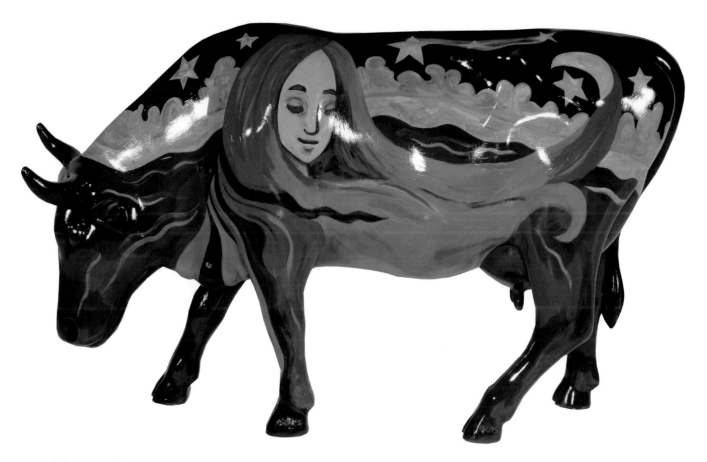

Siren of the Susquehanna
Shani Tucker, Hershey High School
M&T Bank

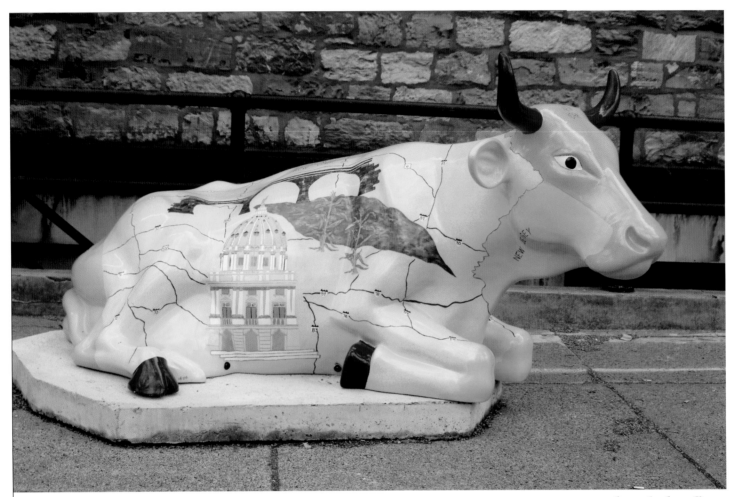

Bessie the Belted Galloway
Amy Kitchen, Millersburg Area High School
Stevens & Lee PC

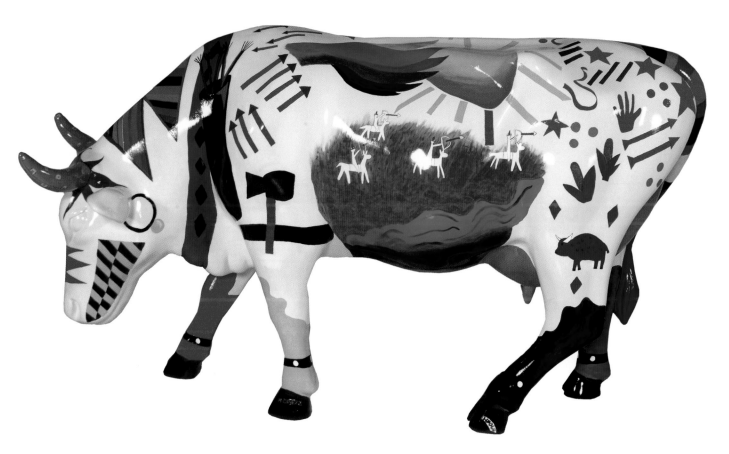

Geronimoo
Amanda Gross, Newport High School
Stevens & Lee PC

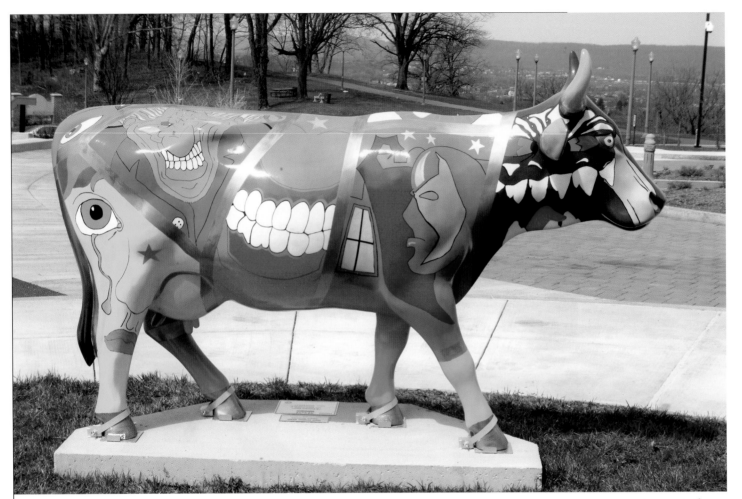

A Twisted Cow
William Gonzalez, Jr., Harrisburg High School
Stevens & Lee PC

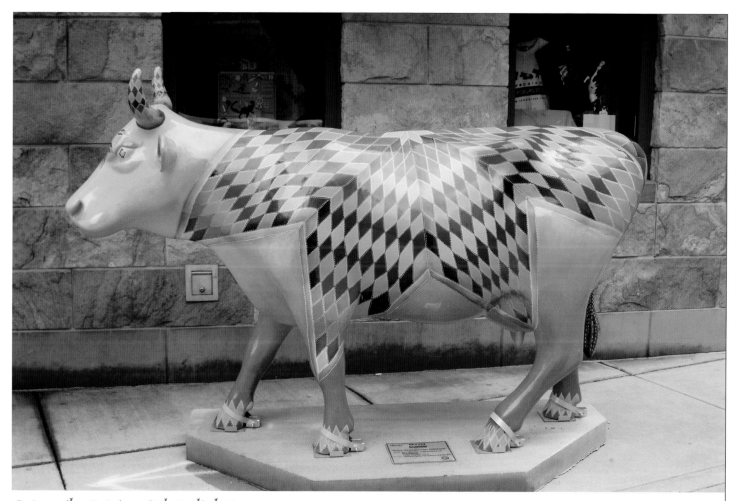

Quincy, the Quintessential Quilted Cow
Ryan Schwalm, Holly Sheesley, and Ryan Hoffman, Halifax Area High School
Whitaker Center for Science and the Arts

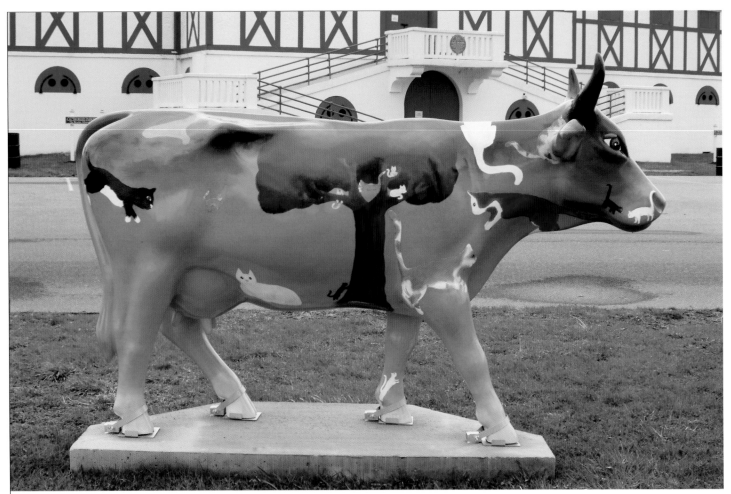

Cattle
Ashley Prah, Susquenita Senior High School
Stevens & Lee PC

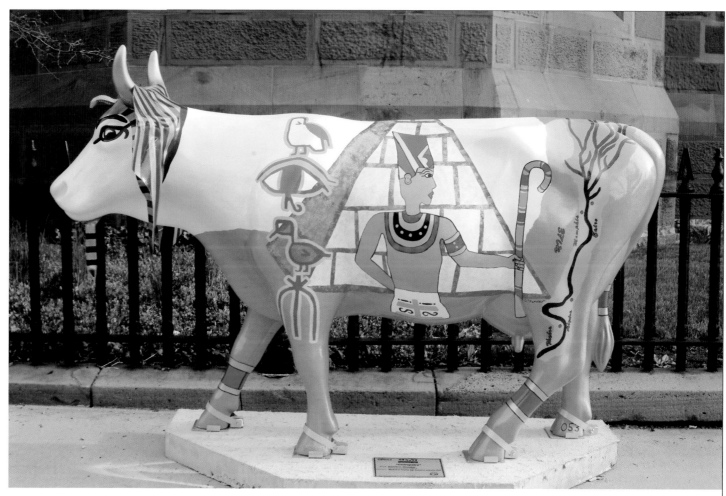

Cowopatra
Danielle L. Shumaker, Greenwood High School
Whitaker Center for Science and the Arts

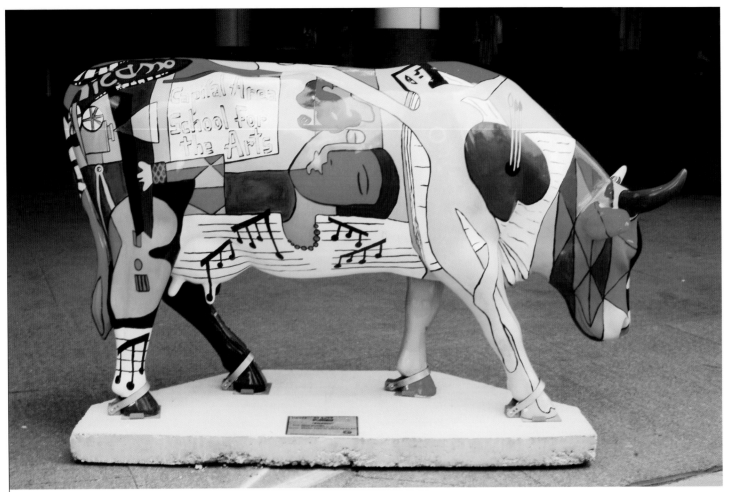

Picowso
Allison Mushalko, Capital Area School for the Arts (CASA)
Whitaker Center for Science and the Arts

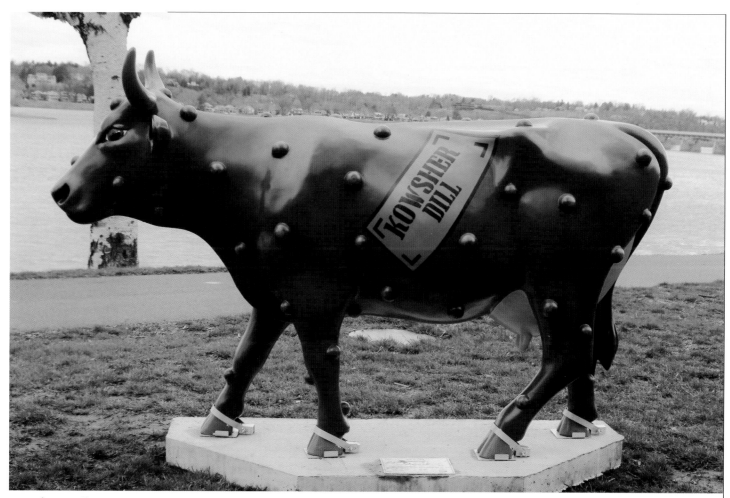

Kowsher Dill
Keiko Kawate, Northern High School
Whitaker Center for Science and the Arts

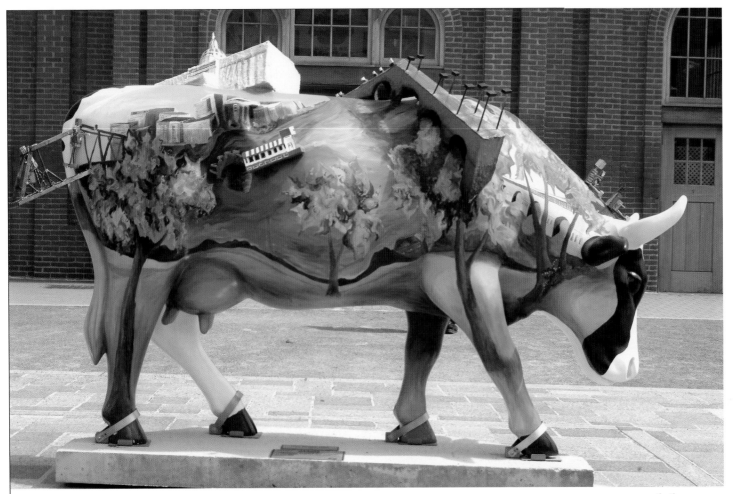

Mooving Toward the Future
Martina Latze and Jakia Handy, Central Dauphin East Senior High School
PFM

Porsche Cowrerra
Chuck Dill
Sun Motor Cars Automotive Group

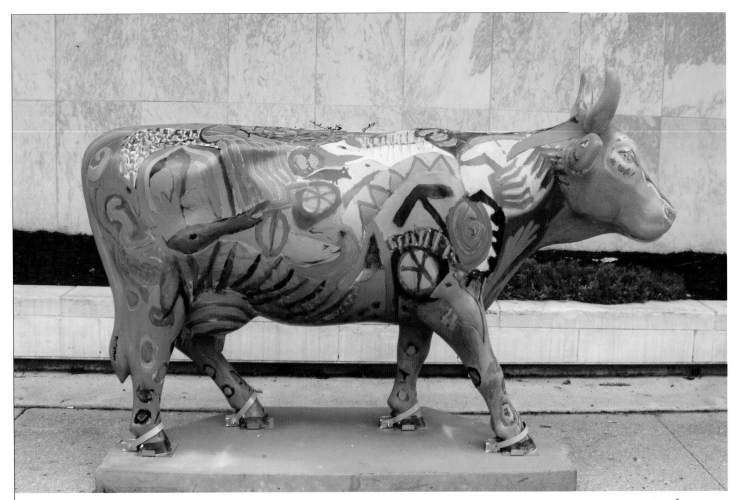

Pastural Domain
Florence Putterman
Whitaker Center for Science and the Arts

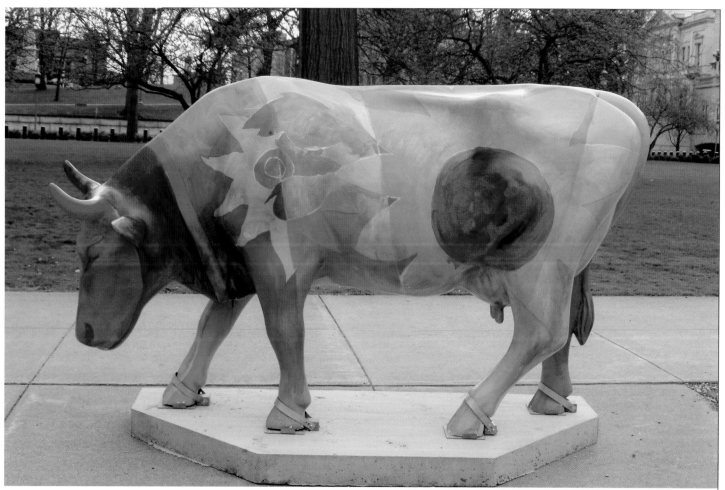

The Bull
Simon Bull
Whitaker Center for Science and the Arts

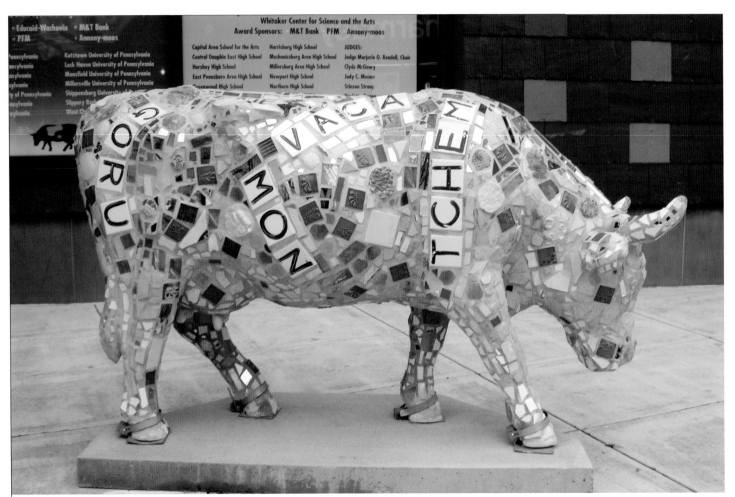

Her 2 (Too)
Isaiah Zagar
Whitaker Center for Science and the Arts

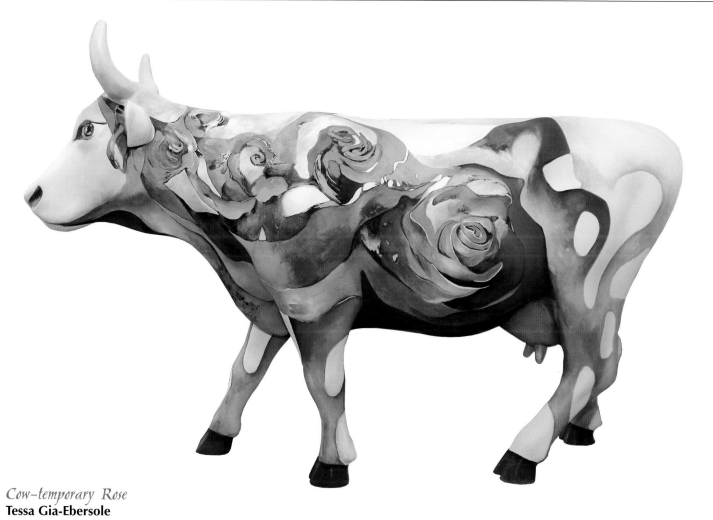

Cow-temporary Rose
Tessa Gia-Ebersole
Whitaker Center for Science and the Arts

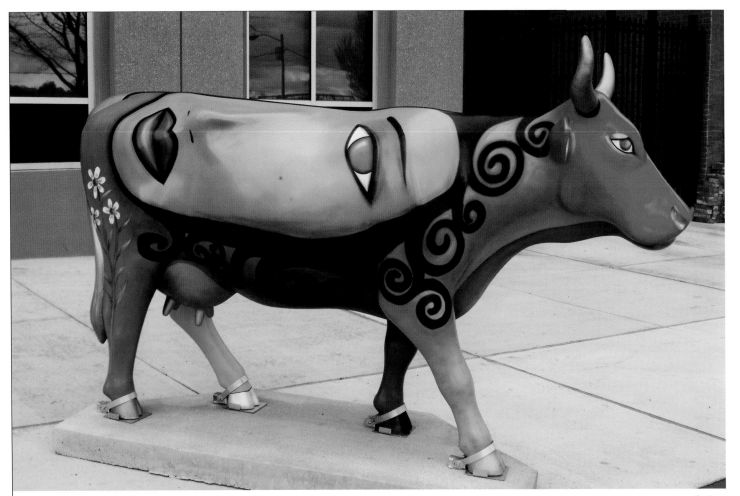

Chelsea
Michael Perez
Whitaker Center for Science and the Arts

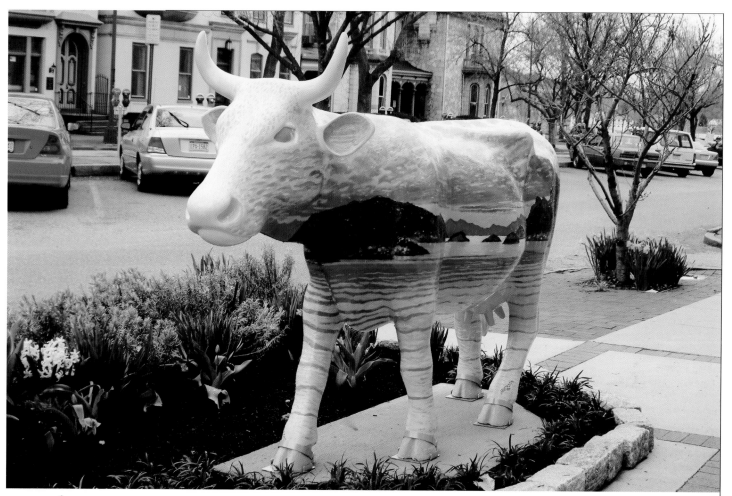

BerMooda Sunset
Howard Behrens
Whitaker Center for Science and the Arts

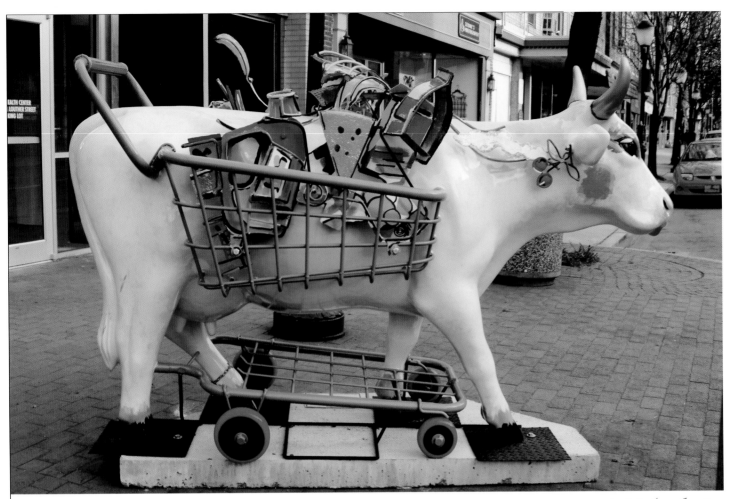

Cart Before the Cow
Richard Ogg
Giant Food Stores

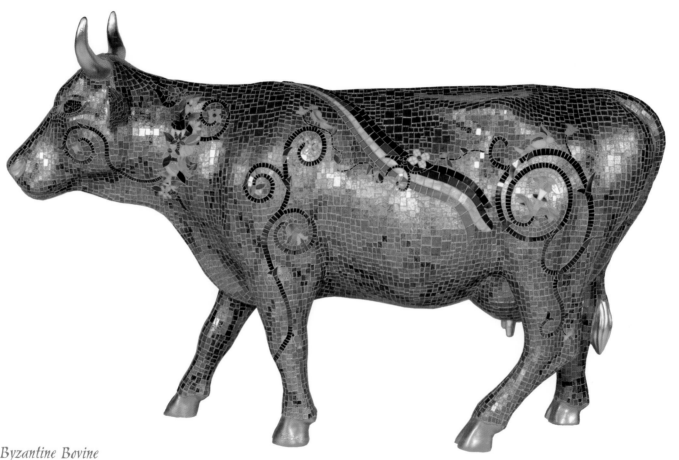

Byzantine Bovine
Elizabeth G. Pellegrini
Citizens Bank

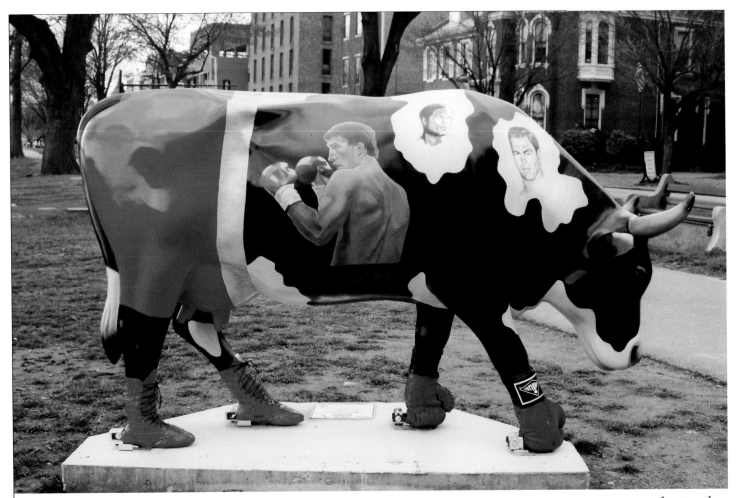

Maxi the Knockout
Patti Brinjac
Antje Freudenberg

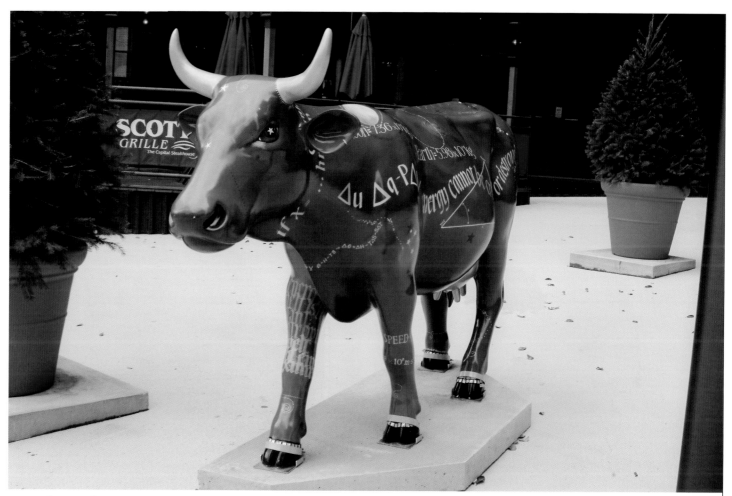

Cowculating the Moon
Sherri A. Trial
Delta Development Group, Inc.

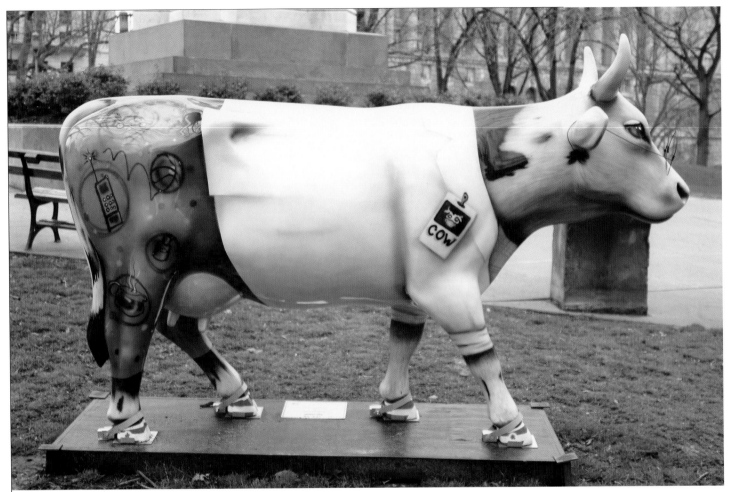

Science Cow
David Leonard
Pennsylvania Chemical Industry Education Foundation

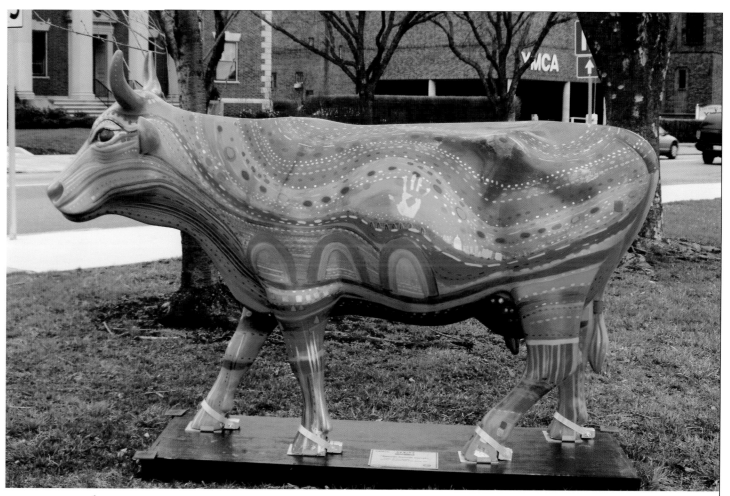

Suscow Hannah Sunset
Janice Snapp
Premier Eye Care Group

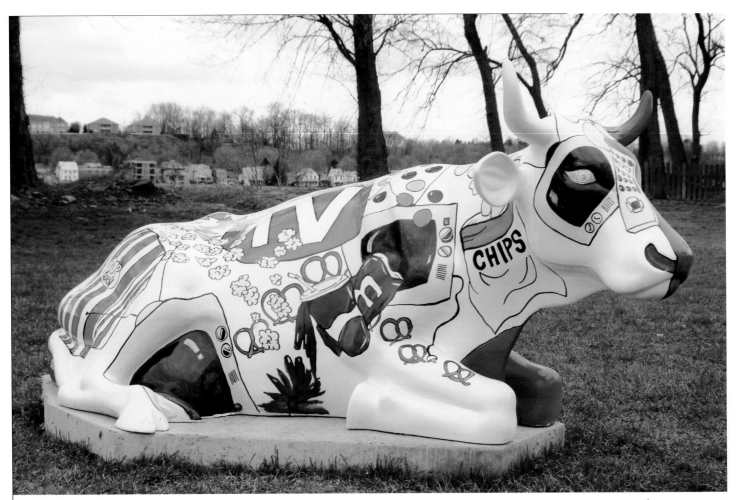

The Cow Potato
Jim Gownley
abc27

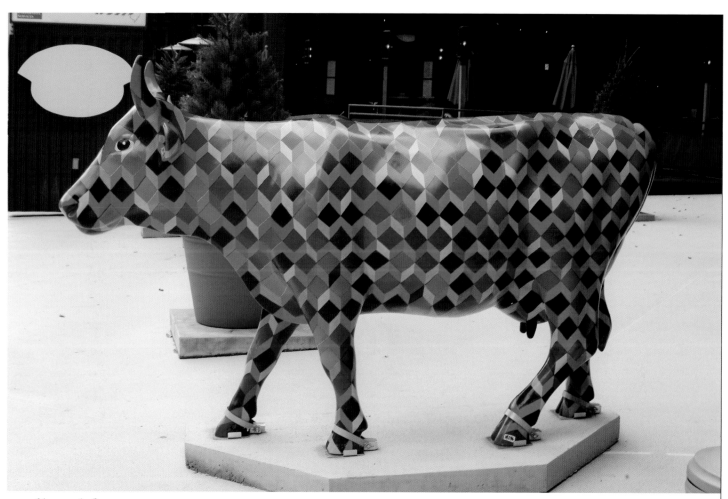

Tumbling Blocks
Marlin E. Bert
Wolf Block & Wolf Block Government Relations

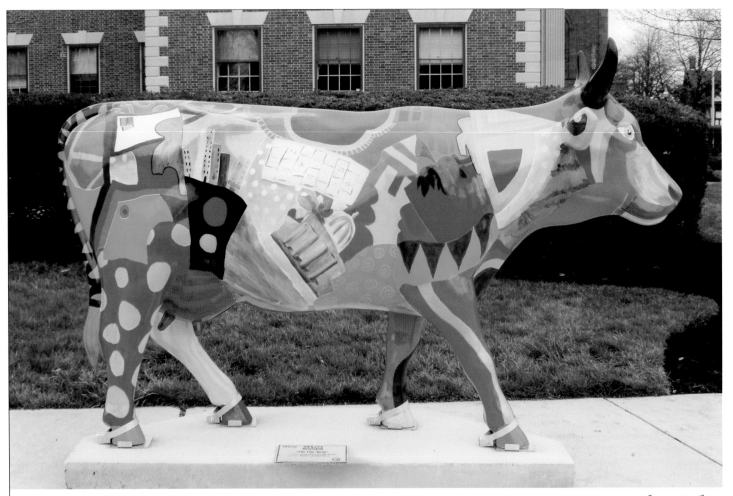

The City 'burg
Jump Street Paintin' Lively
Friends of Jump Street

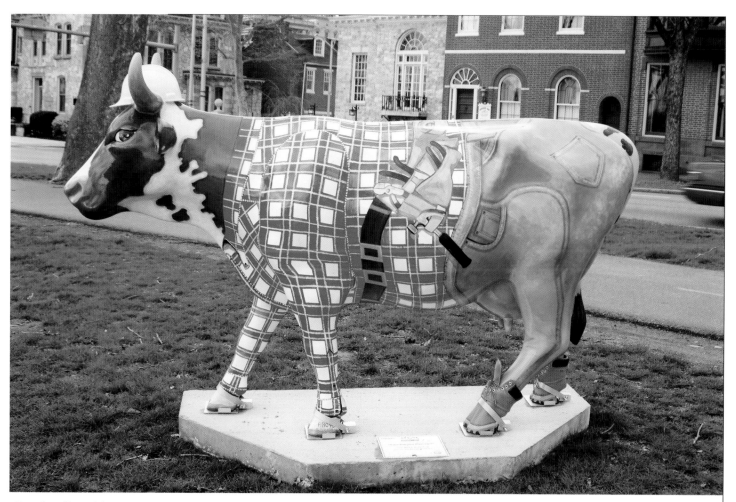

Cowstruction Moonager
Mary B. Hochendoner
The Quandel Group, Inc.

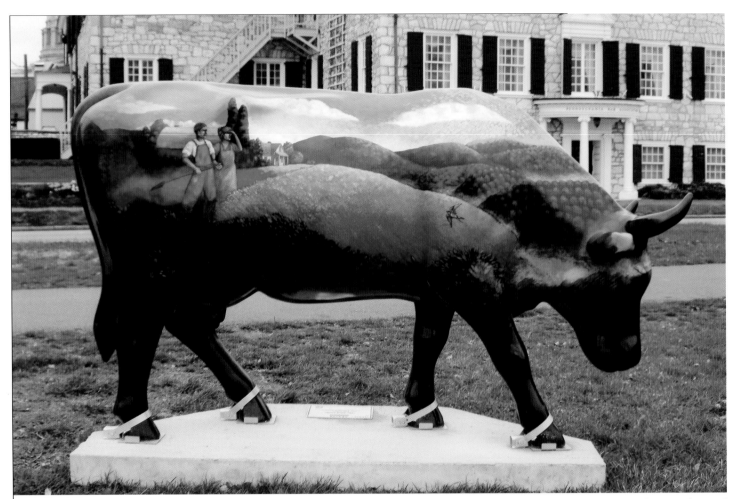

The Good Earth
Brett Greiman
Fulton Bank

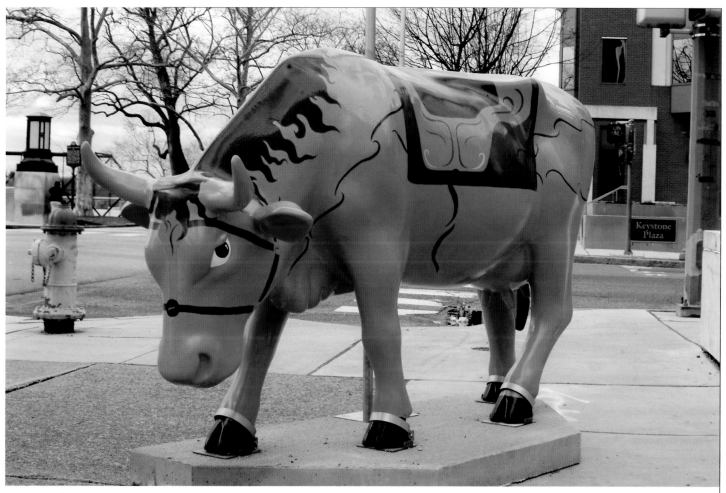

Cowrousel
Tara Reeder & Antonio Ortiz
Cornell Companies

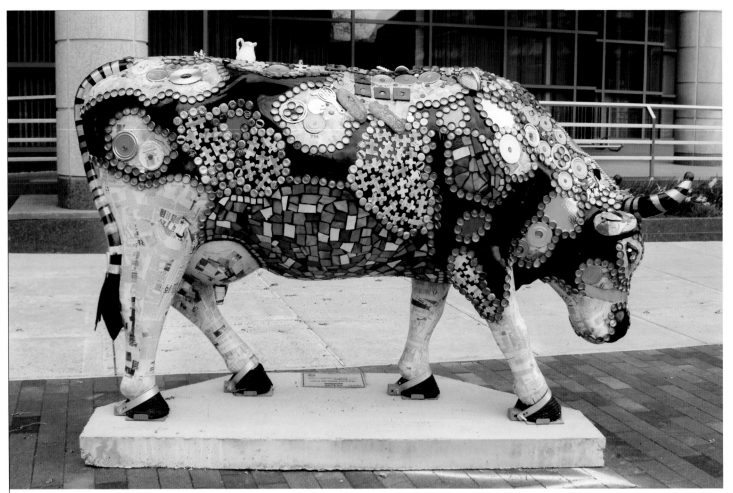

Recycled Reba, the Cow
Gail Zambor
Modern Landfill-Republic Services, Inc.

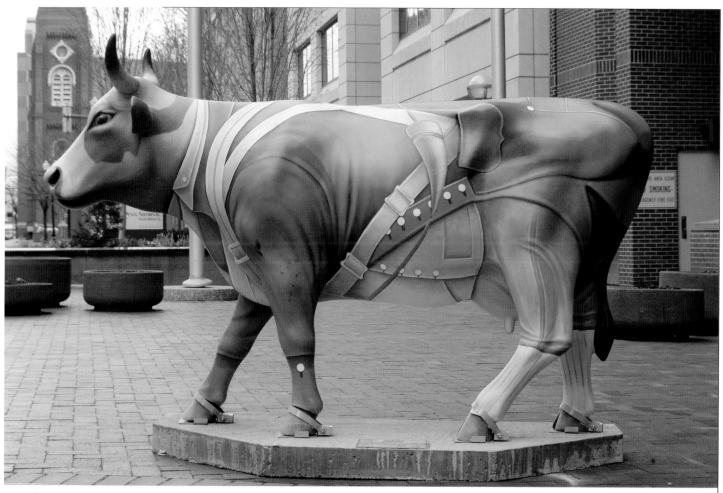

Revolutionary War Cow
Jared Bader
Country Meadows Retirement Communities

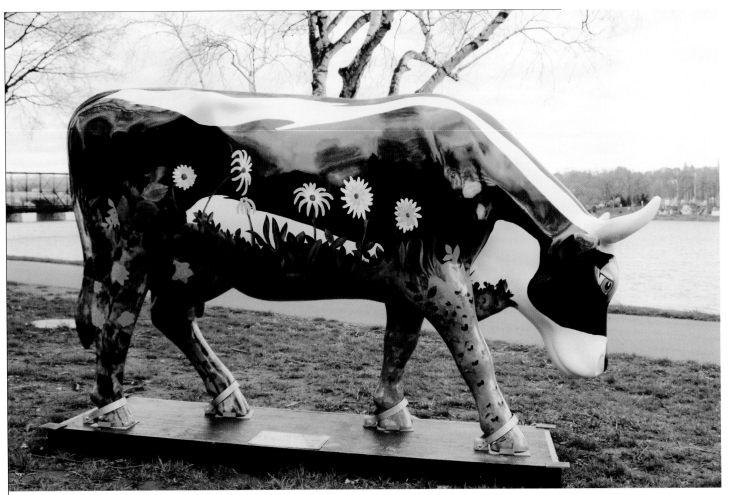

Flower, A Cow by Any Other Name
Della J. Hoke
Roger Ostdahl and Maureen Callahan

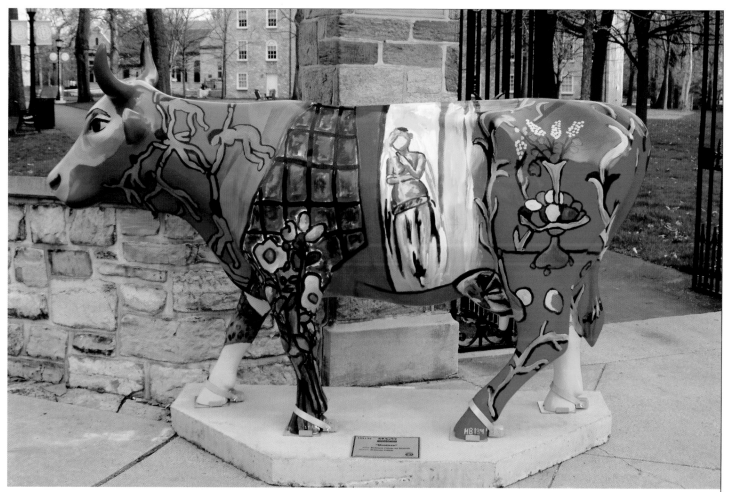

Mootisse
Dickinson College Art Students
Dickinson College

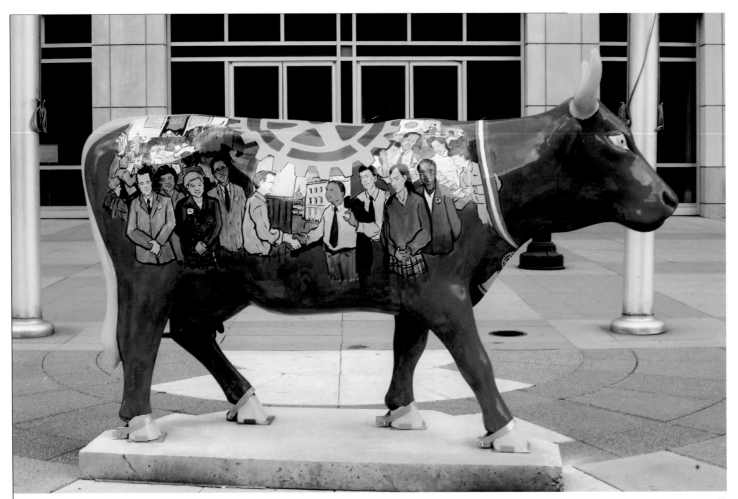

Rotary Belle
Gene A. Suchma
Rotary Club of Harrisburg

Amazing Moth Cow
Rob Evans
Buchanan Ingersoll PC/Attorneys

Café Cow
Zora Janosova
Alley on 2nd

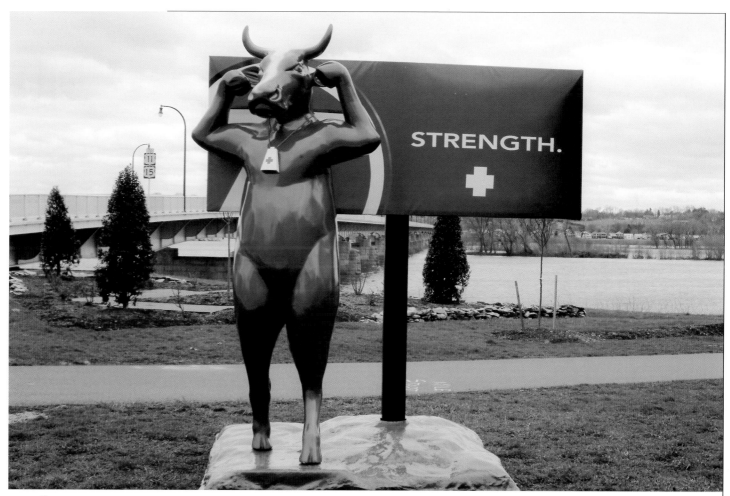

Standing Strong in our Cow-munities
Cenyx Corporation
Capital Blue Cross

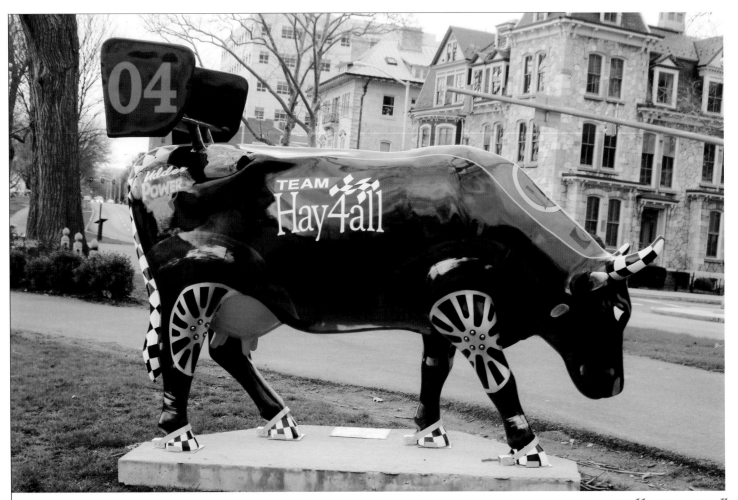

Bobby Hay-4-All
Mary Lundeen
Bobby Rahal Automotive Group

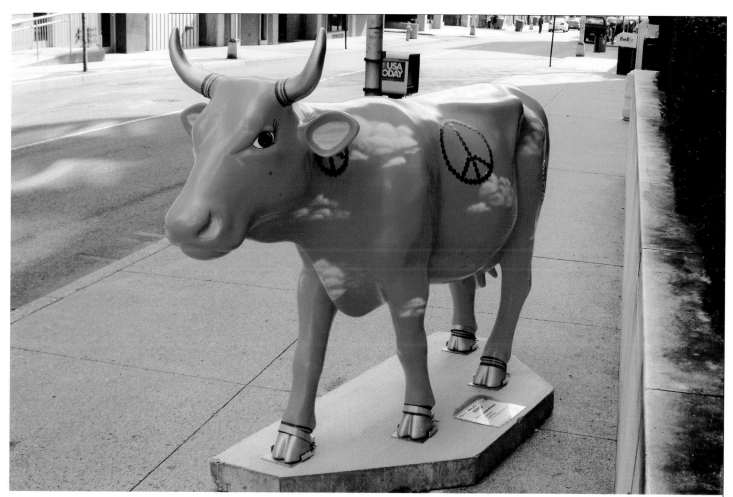

Nicole's Dream of Peace
Employees of Coin Wrap, Inc.
Coin Wrap, Inc.

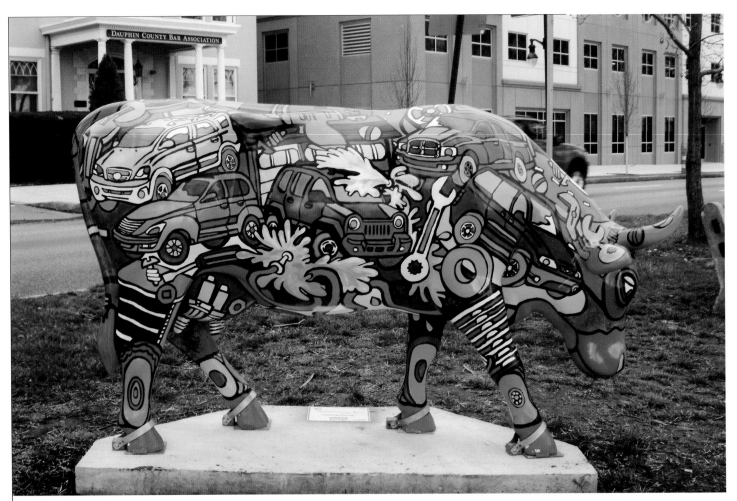

Brenner Mooters
Kelly Ross
Brenner Family of Dealerships

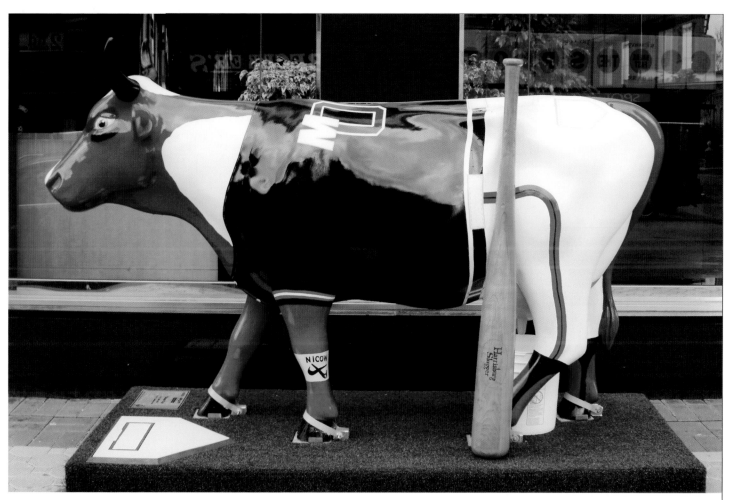

Senator Cow
Garry Price
Commerce Bank

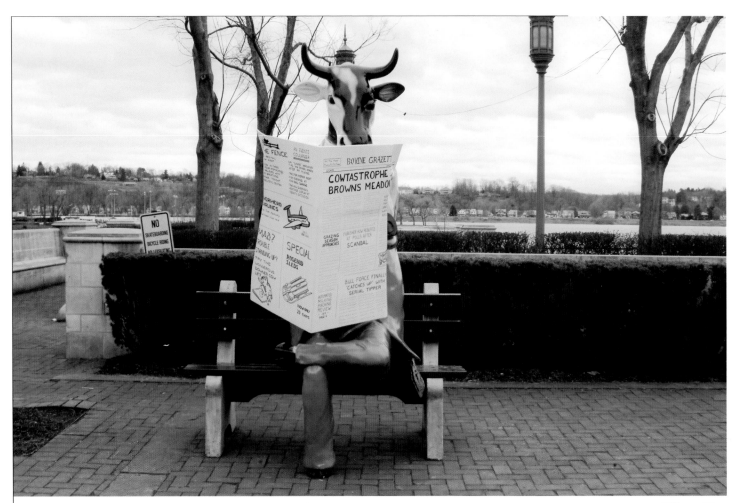

Citizen Kow
Cenyx Corporation
Harrisburg News Company

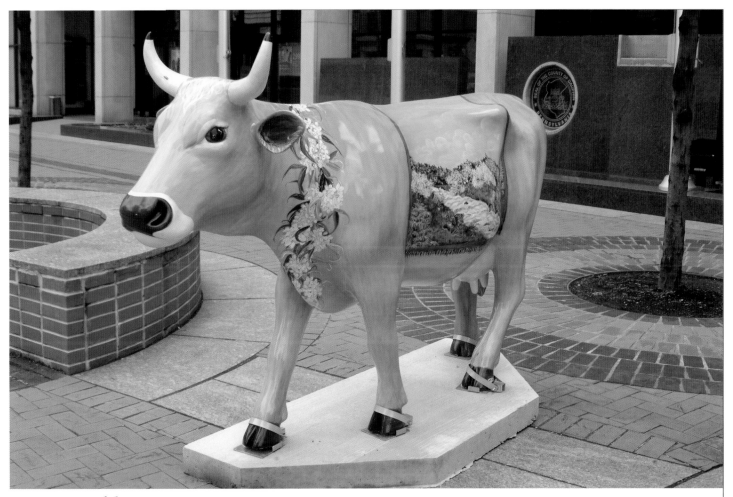

Ms. Penni Symbols
Kim Hallinin
Dauphin County Economic Development Corporation

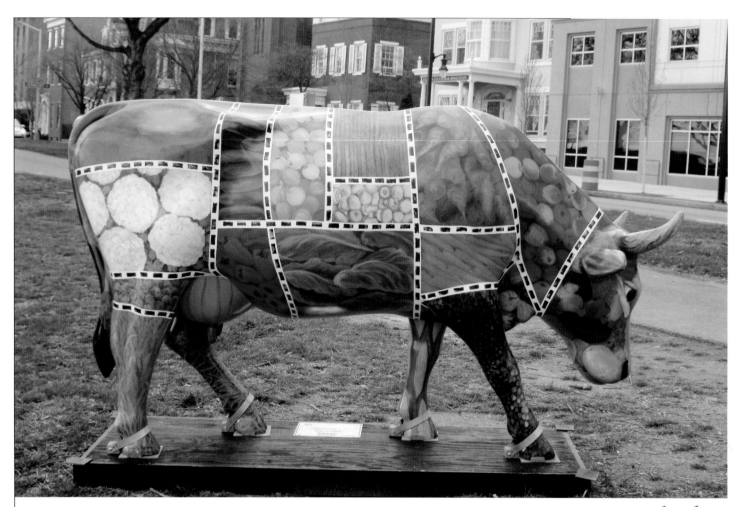

Balanced Diet
Marion K. Stephenson
Karns Quality Foods

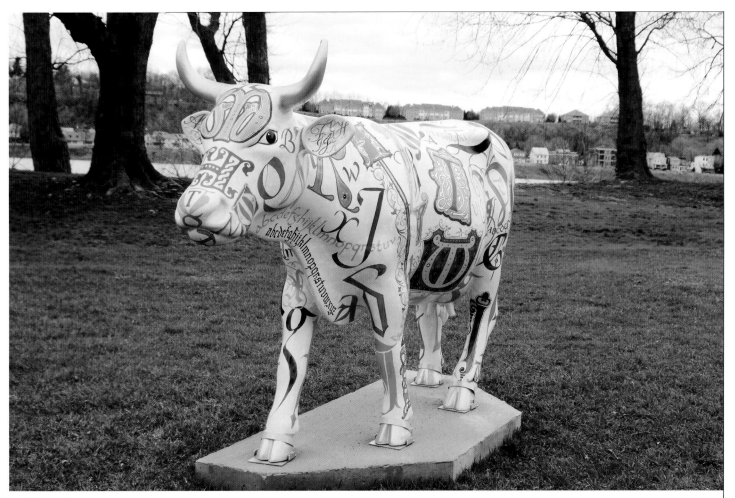

Calligraphicow
Susan Leviton-Levworks
G.R. Sponaugle & Sons, Inc.

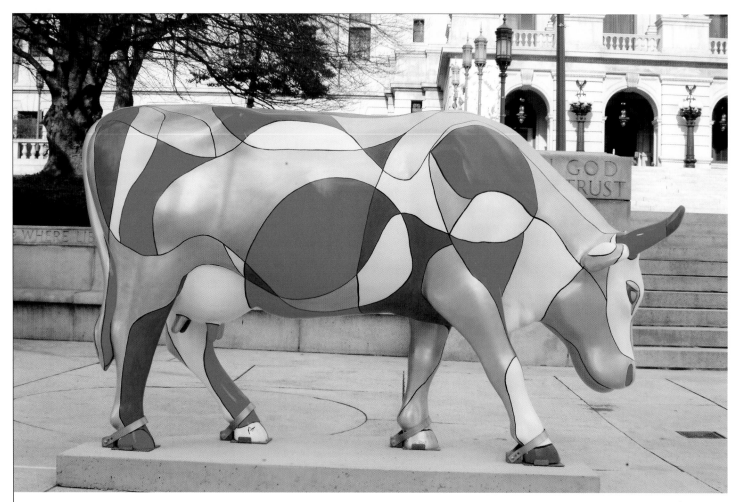

Amoorica
Victor Viser
Kirkpatrick & Lockhart LLP

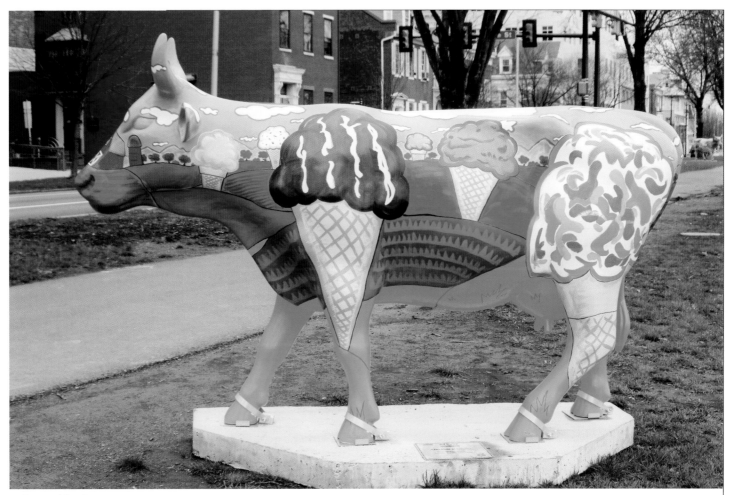

The Field of Creams
Michael Moppin
Hershey's Ice Cream

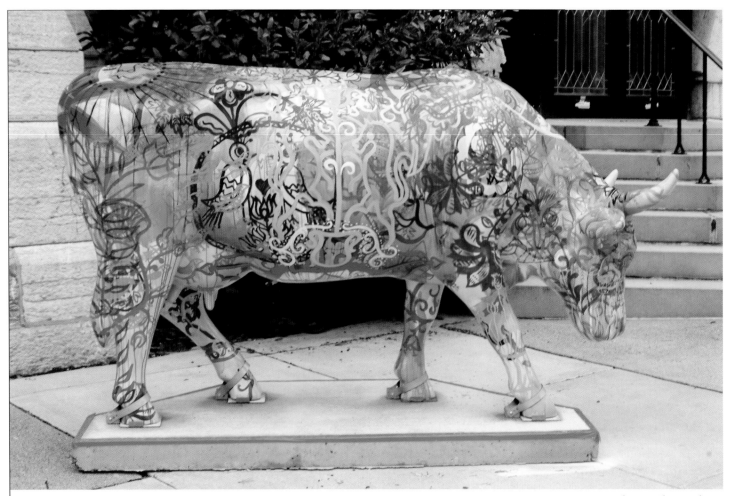

A Modernized Tradition
Michael Holland and Andrea Liantonio
Messiah College

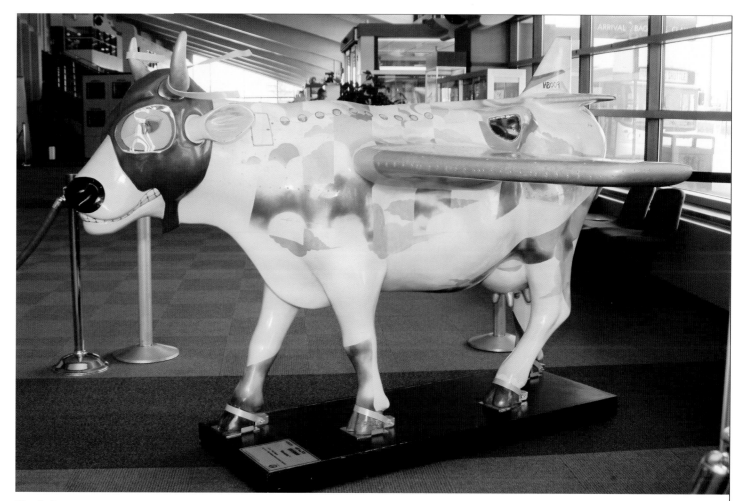

Boviator
Paul Nagle
Harrisburg International Airport

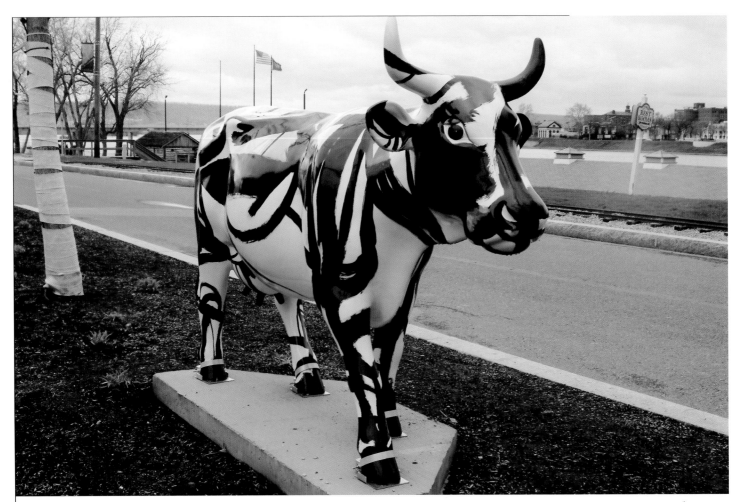

Kline Kow
Earl R. Blust
Michak Teeter & Lewis LLC

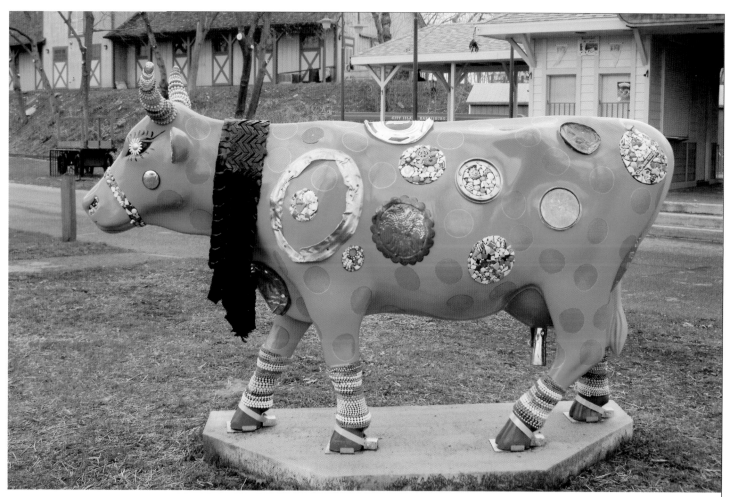

Recy-Cow
Jan and Jeff Urey
Just Cabinets of Harrisburg

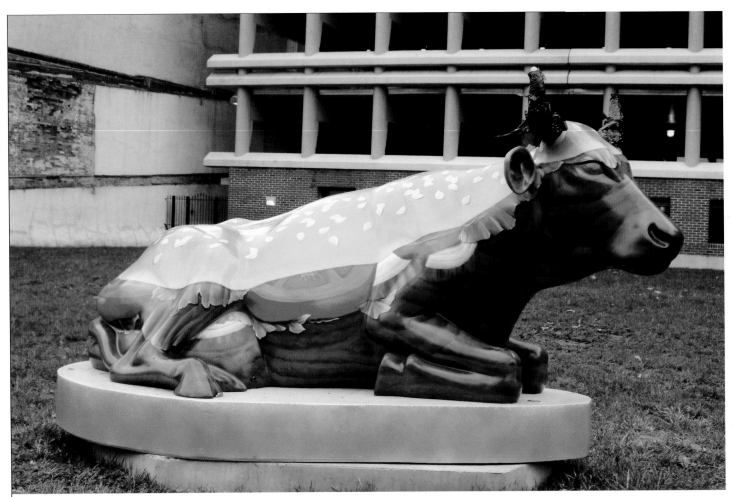

The Harrisburger
Kathi Everett Yarnall
Pennsy Supply, Inc.

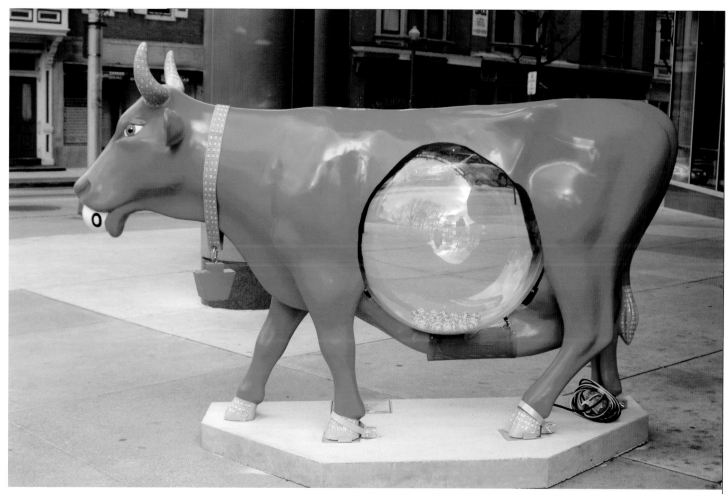

Lotto Moola
Amy Rajakovic
Pennsylvania Lottery

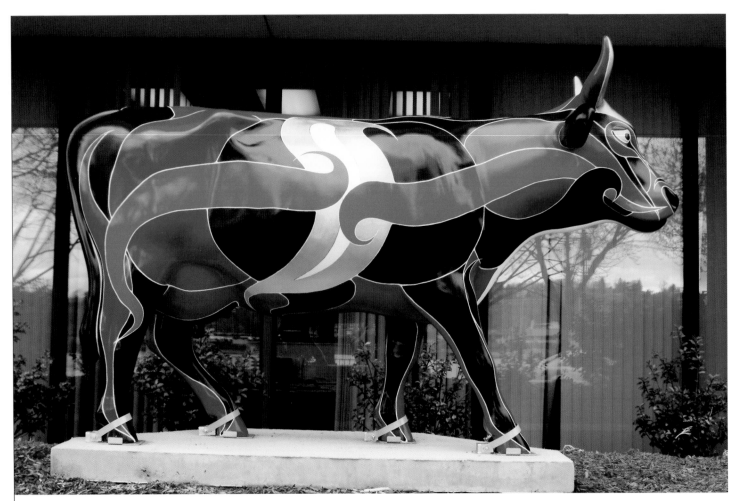

Musa #3
Yesid Gomez
McNees Wallace & Nurick LLC

Holy Cowstruction
Yesid Gomez
Novinger Group, Inc.

The Red Dress Cow
Roberta K. Davis
PinnacleHealth

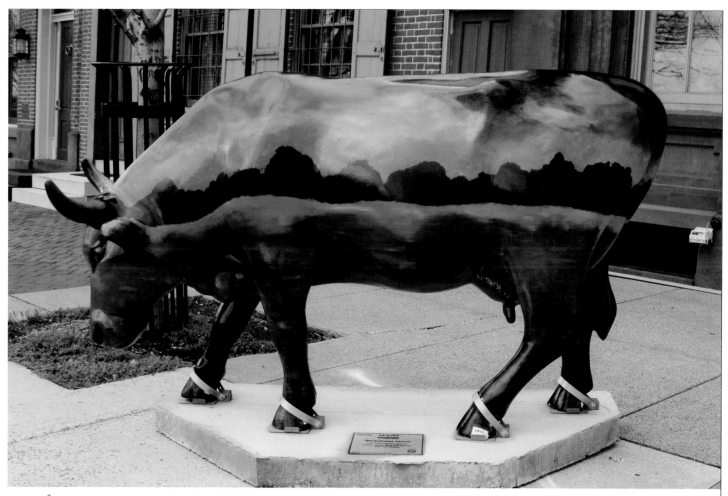

Susquehanna Sunset
Carrie Wissler-Thomas
Pennsylvania Automotive Association

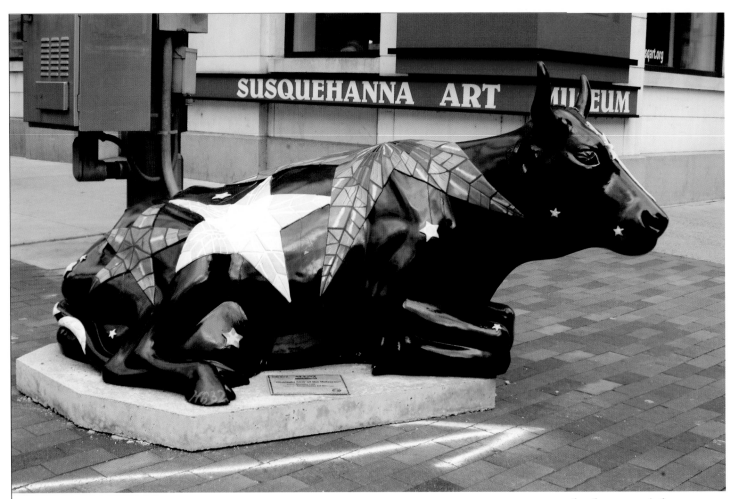

Midnight Cow of the Universe
Beverlee Lehr
Susquehanna Art Museum

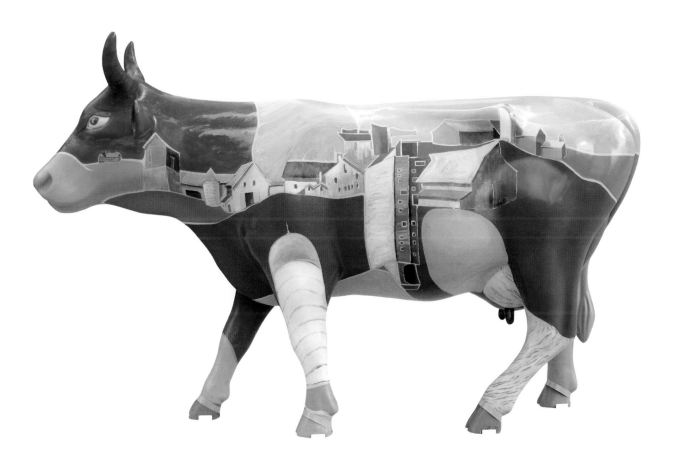

Mooving Home to Pennsylvania
Jim Bright
Pennsylvania Chamber of Business and Industry

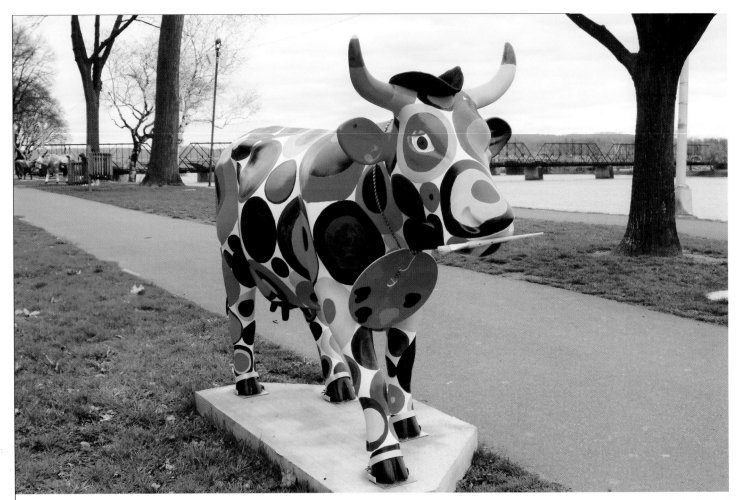

Got Spots?
Amy P. Meininger
Wilsbach Distributors, Inc. for Lebanon Valley College

Cow-isthenics
Lynn Kennedy-Putt
Rutter's

From Moo to You
Earl R. Blust
ADADC Mid-East, The Pennsylvania Dairy Promotion Program &
The Mid-Atlantic Dairy Association

Good Ole' Farmlife
Tammi A. Rodman
Turkey Hill Dairy

Cosmic Wave Cow
Sandi Slone
Greenlee Partners, LLC

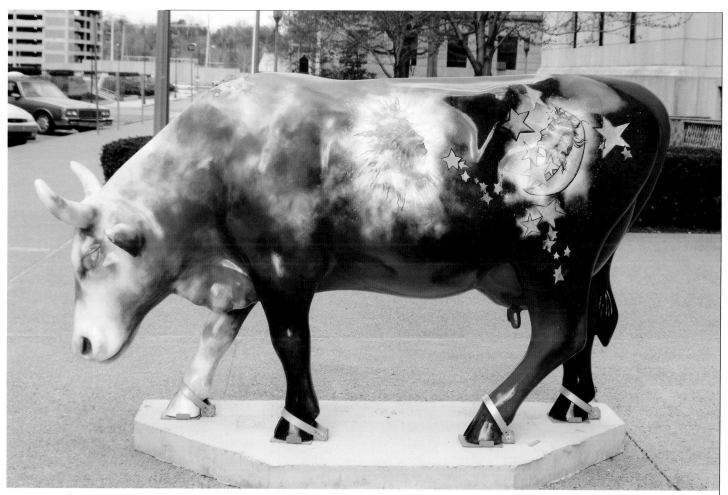

Divine Celestial Bovine
Alix D. McCown
Wanner Associates

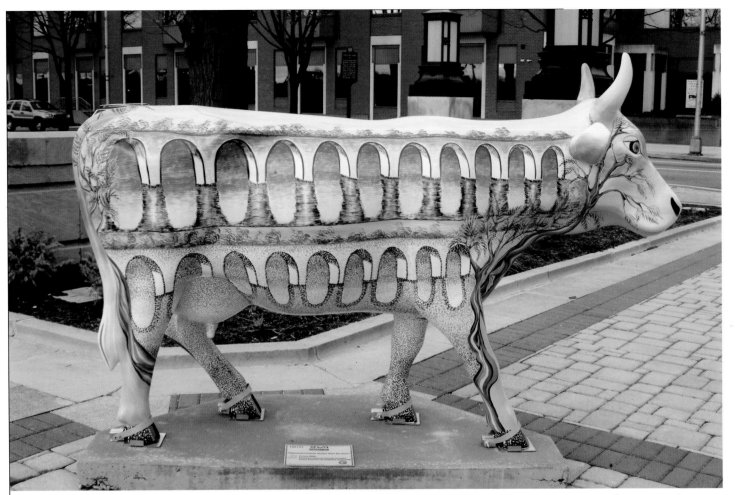

Impressiomooism; Arches Over the River
Darlene Miller
Harrisburg Regional Chamber &
Capital Region Economic Development Corporation

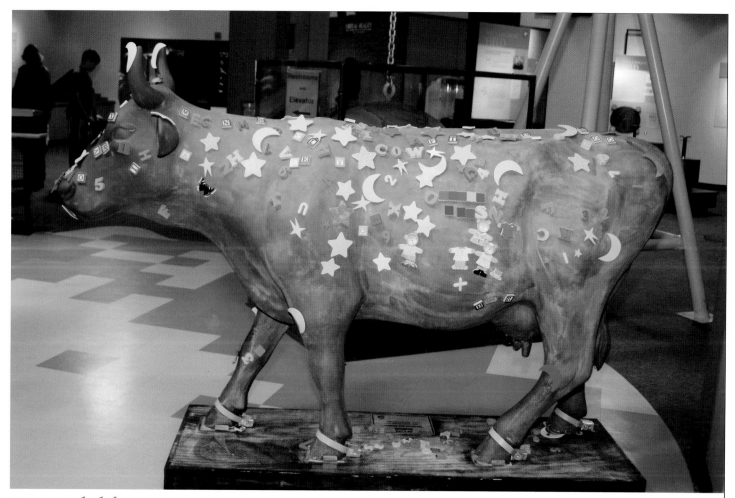

Moovers and Shakers
Jessica Marquez-Gates
Harrisburg Magazine, Inc.

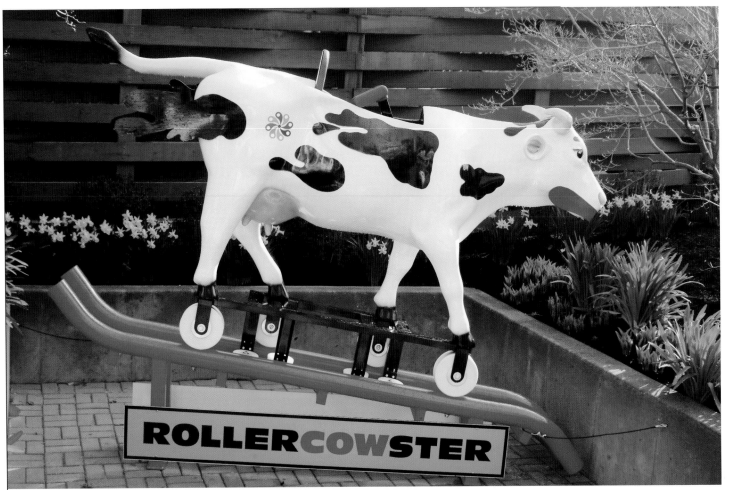

ROLLERCOWSTER

Roller Cowster
Bill Dussinger
Hersheypark

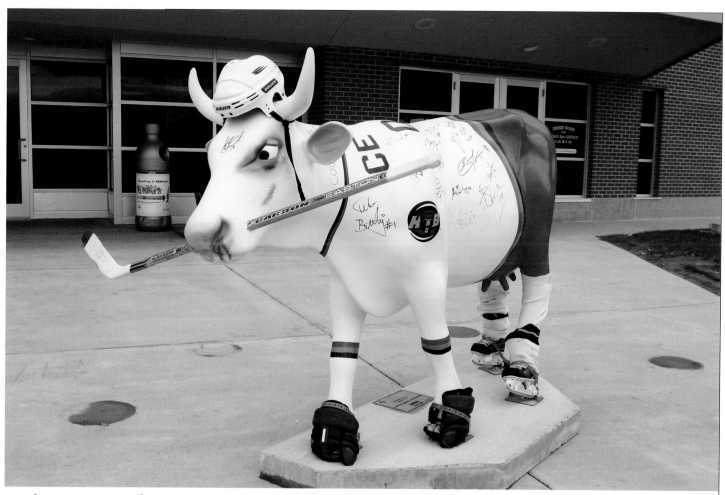

Hershey Bears Ice Milk & Biscuits
Curt Rohrer
Hershey Bears

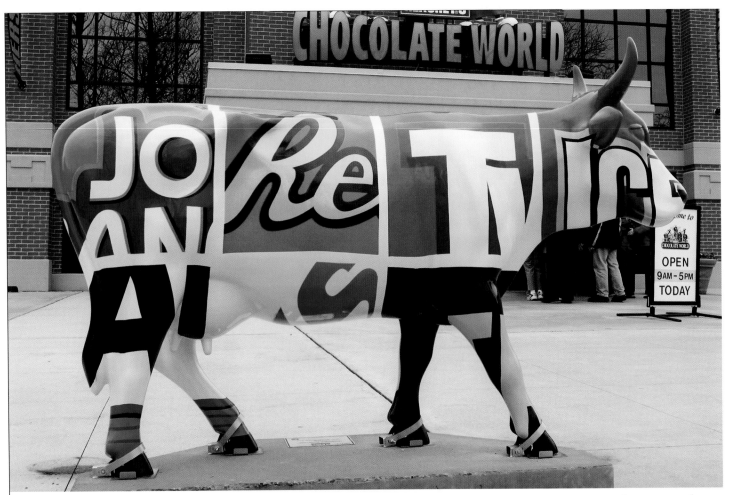

Confection Cowlection
Wayne Fettro
Hershey's Chocolate World

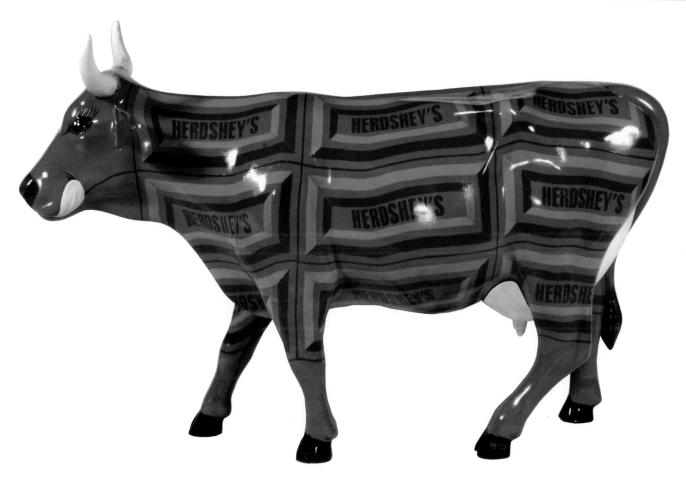

Ms. Udder Lee deLishiss
David E. Cook
Hershey Foods Corporation

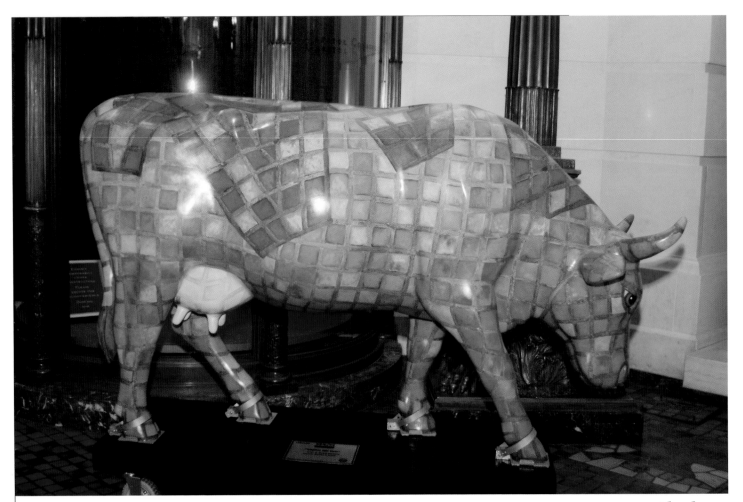

Capitol Tile Cow
G. Strang-Giordano
Holsten & Crisci

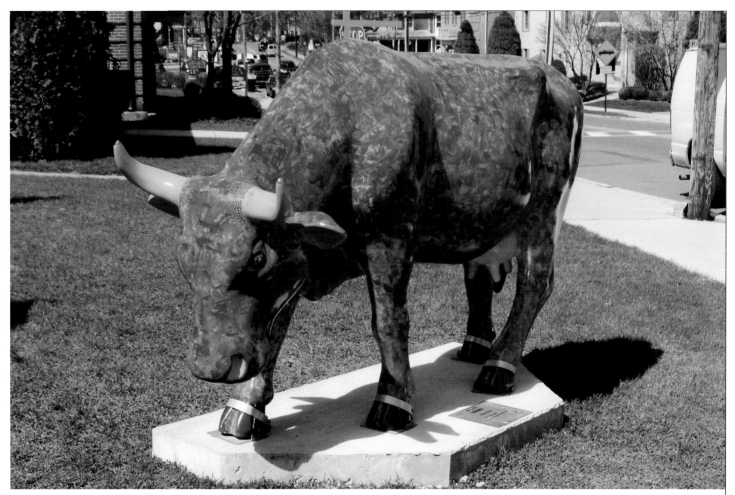

Moo Blue
Claire Giblin
Highmark Blue Shield

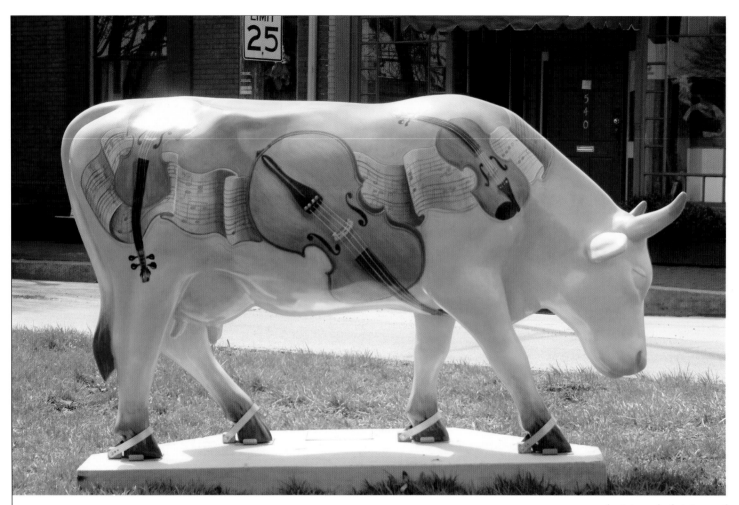

A MoozArt Moment
Carol Oldenburg
Lois Lehrman Grass

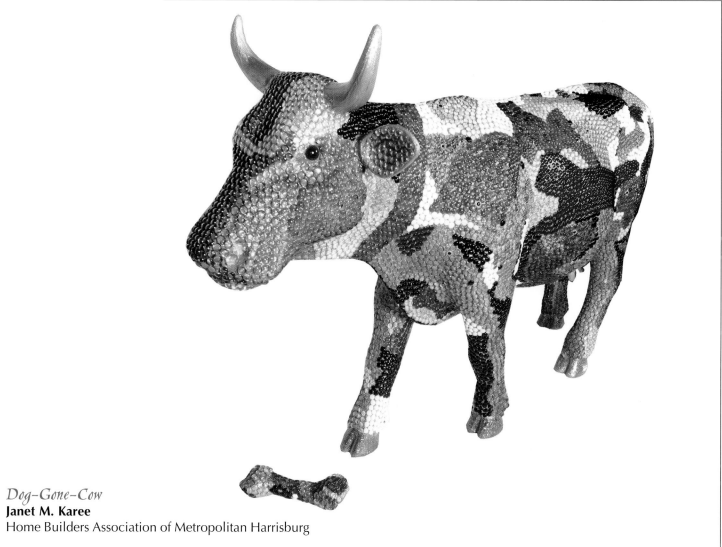

Dog-Gone-Cow
Janet M. Karee
Home Builders Association of Metropolitan Harrisburg

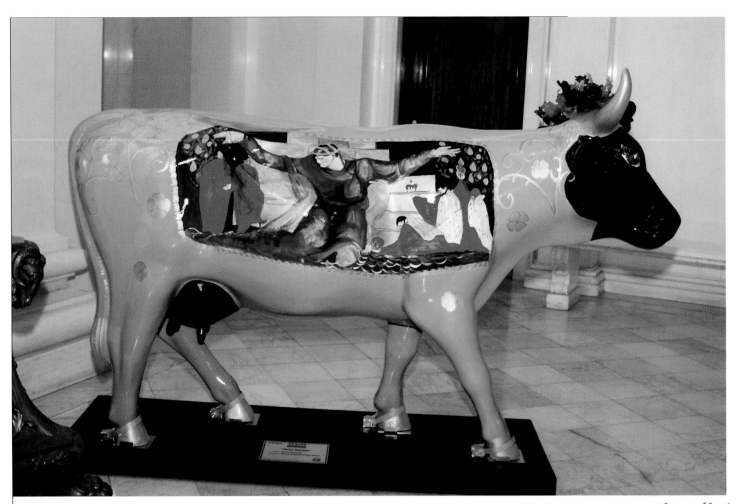

Violet Oakleaf
Nancy Thompson
Malady & Wooten Public Affairs

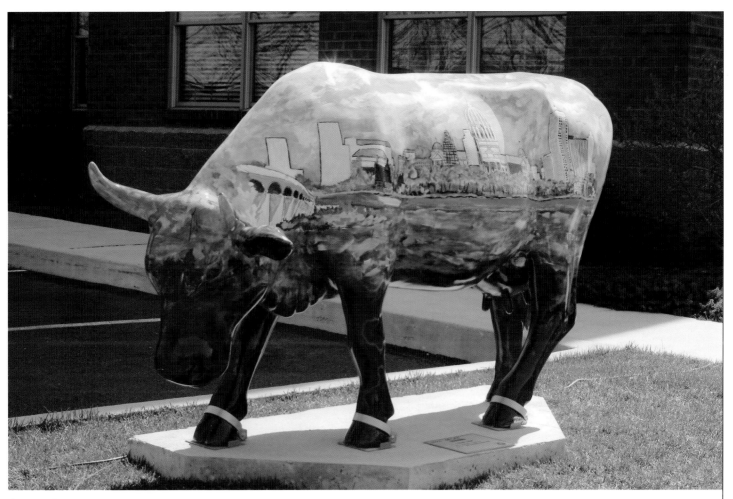

River Cow
Thomas L. Feldmann
Jack Gaughen Realtor ERA

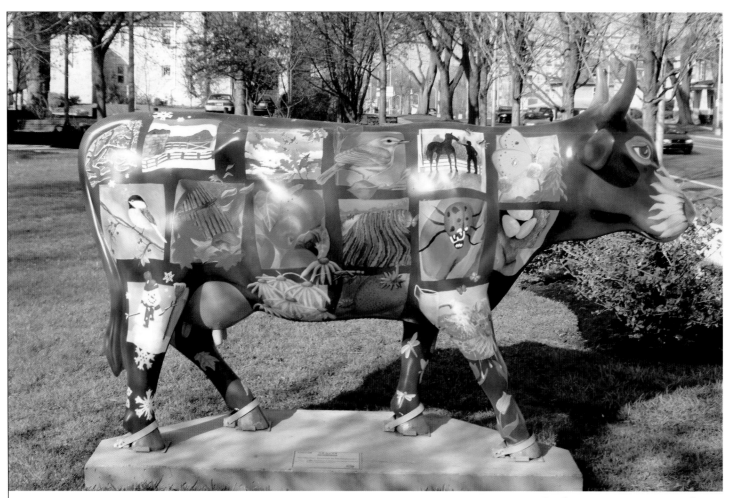

Cow-lendar, Seasons in Pennsylvania
Cathi Bertrand & Milton Hershey Students
Milton Hershey School

Christmoos Cow
Simon Bull
Kathie's Christmas & Collectibles

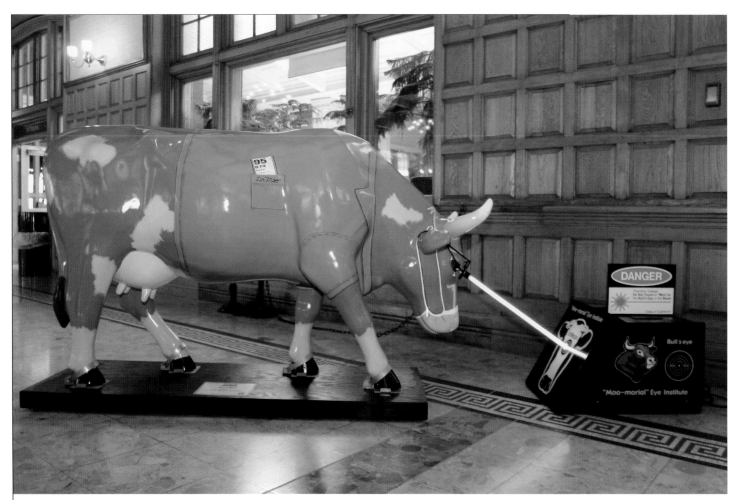

The LazHerd
Jill Hassall Rees
Moo-morial Eye Institute

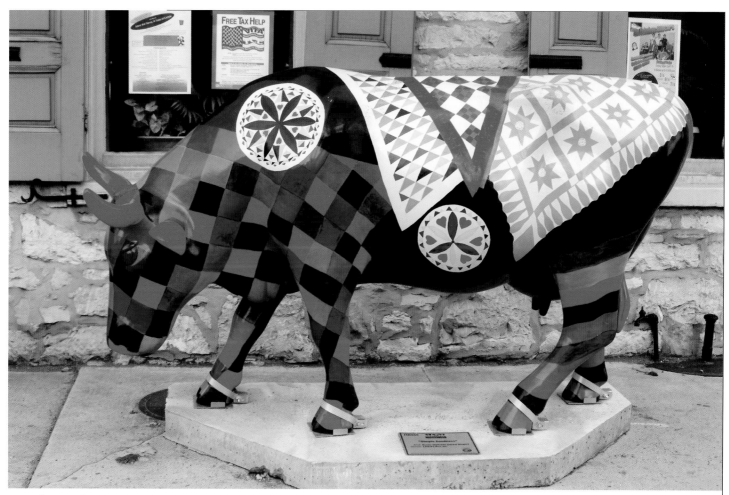

Simple Goodness
Bonnie Highlands and Pat Wingard
Land O'Lakes, Inc.

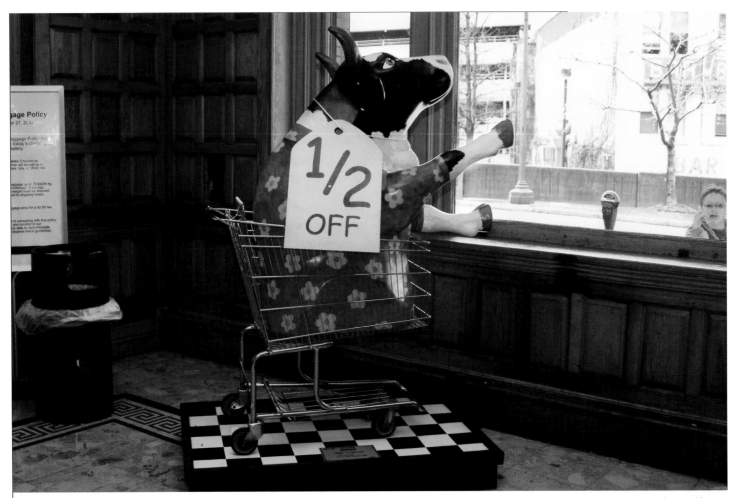

Ollie: 1/2 Off Cow
Tim Reed
Ollie's Bargain Outlet

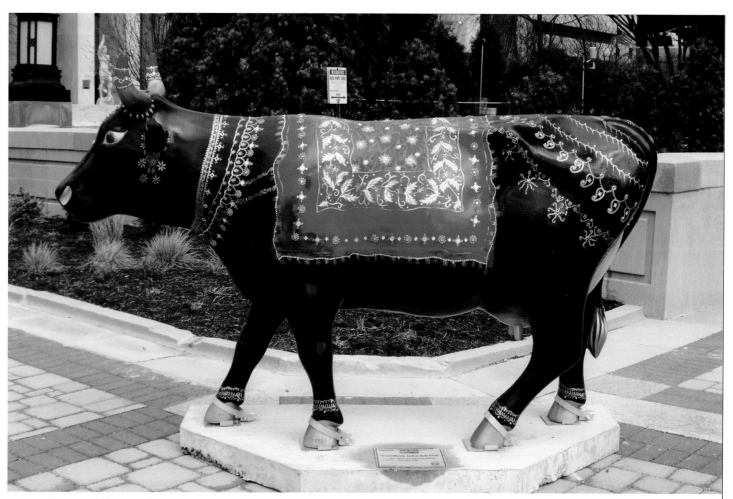

Kaamdhenu: Indian Holy Cow
Jupi T. Das and Leena Shenoy
Passage to India

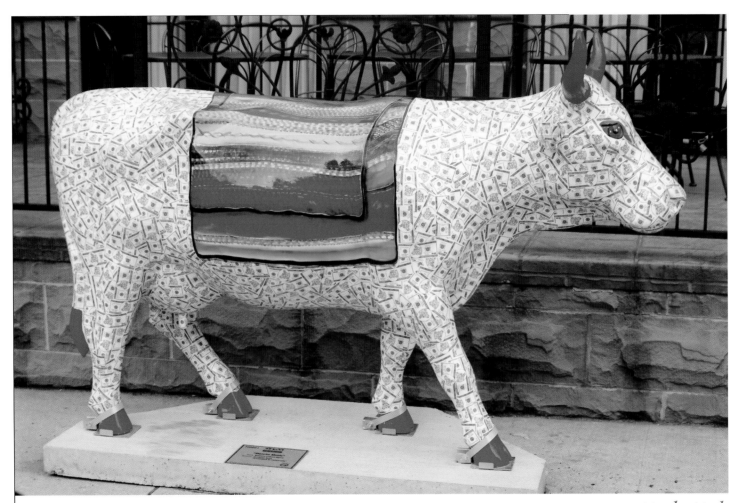

Moocho Moola
Rebecca Pollard Myers
Orrstown Bank

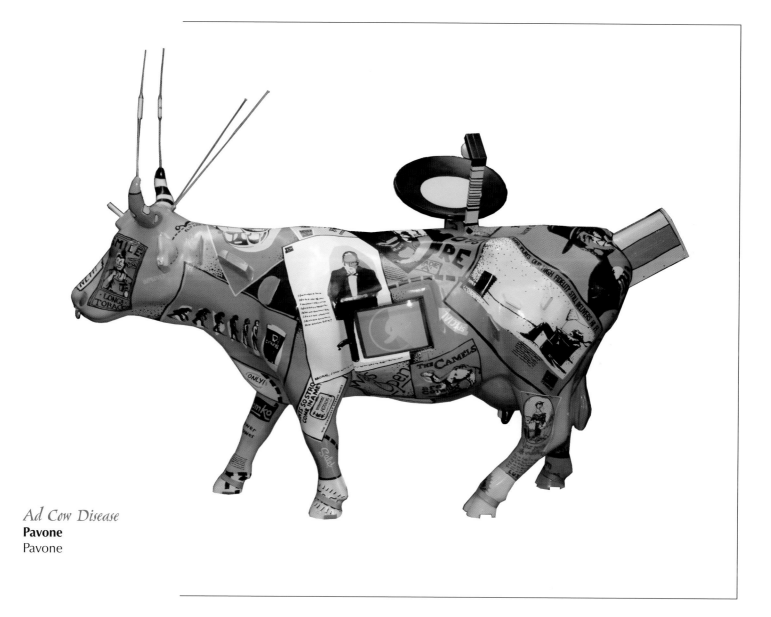

Ad Cow Disease
Pavone
Pavone

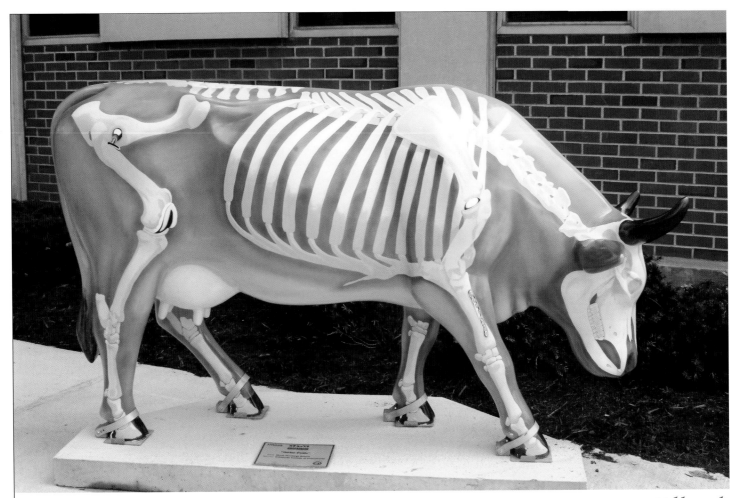

Udder-pedic
Biruta Akerbergs Hansen
Orthopedic Institute of Pennsylvania

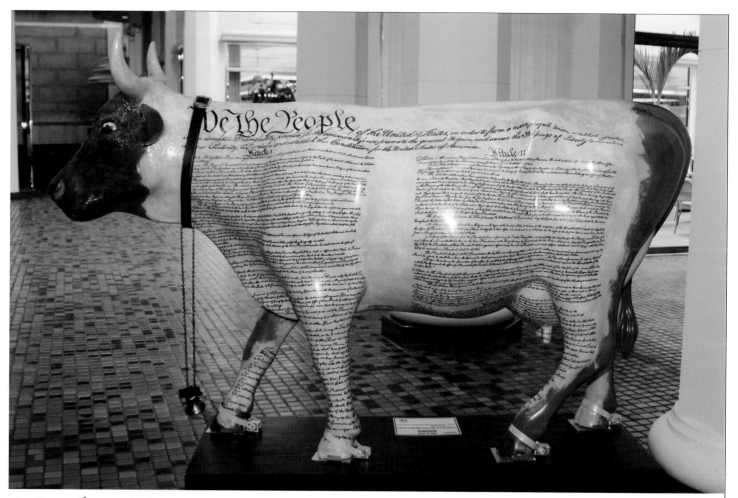

Constance, the Constitution Cow
Marie Hoggs
Pennsylvania Manufacturers' Association

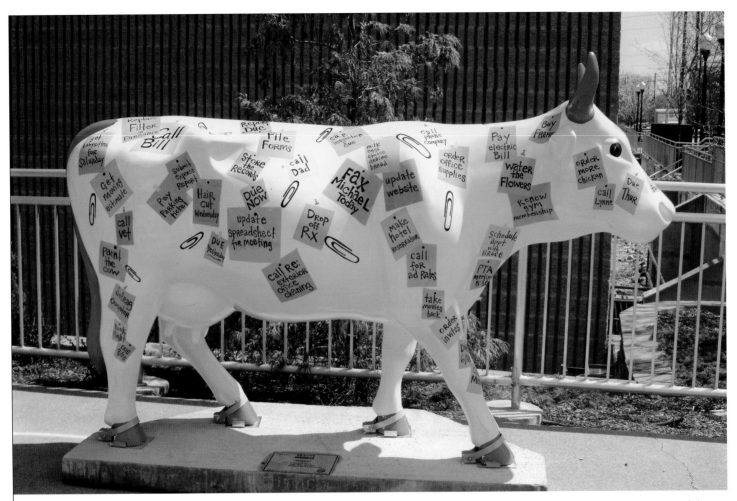

Memoo
A. Michelle Blace
PRK-MOR, Inc. and Walker's Art & Framing, Inc.

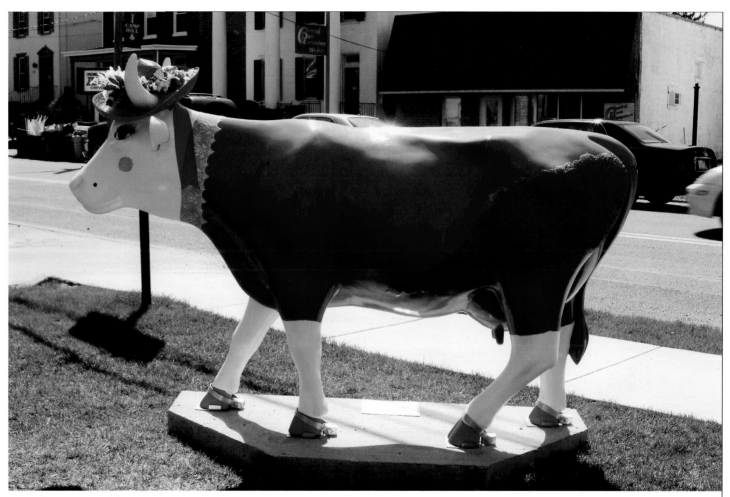

Moodame Mootilda
Lyn Marsh
Pennsylvania State Bank

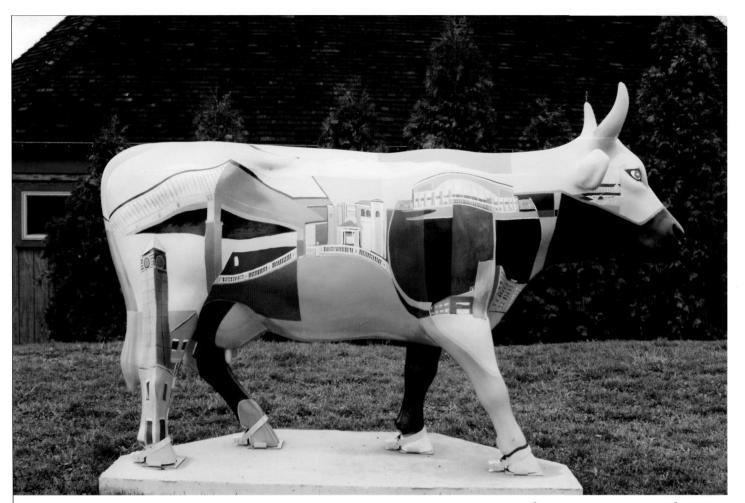

Harrisburg Construction...on the Moove
Jim Bright
Reynolds Construction Management, Inc.

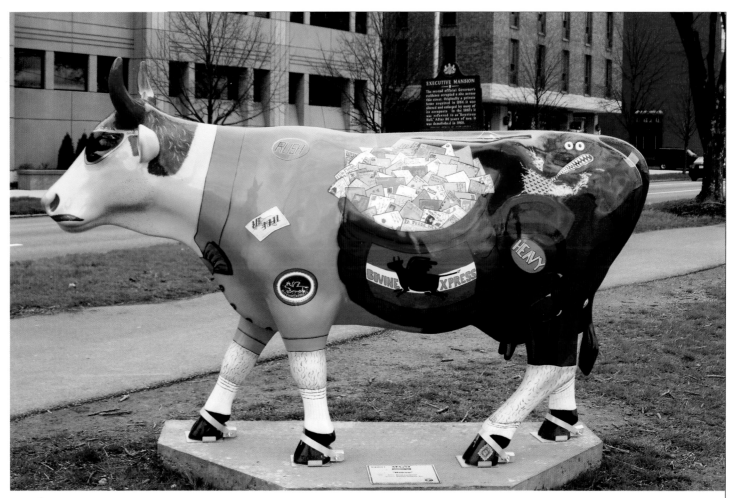

Mailcow
Dondi Gamberini
Priority Systems, Inc.

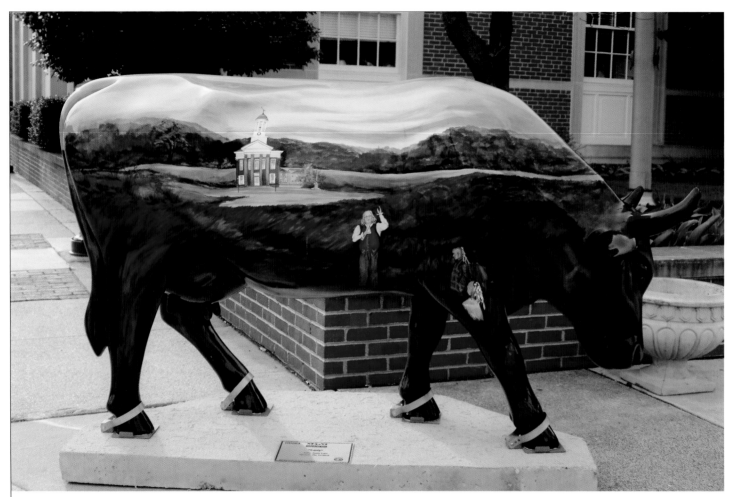

Carly
Linda Luke
The Sentinel

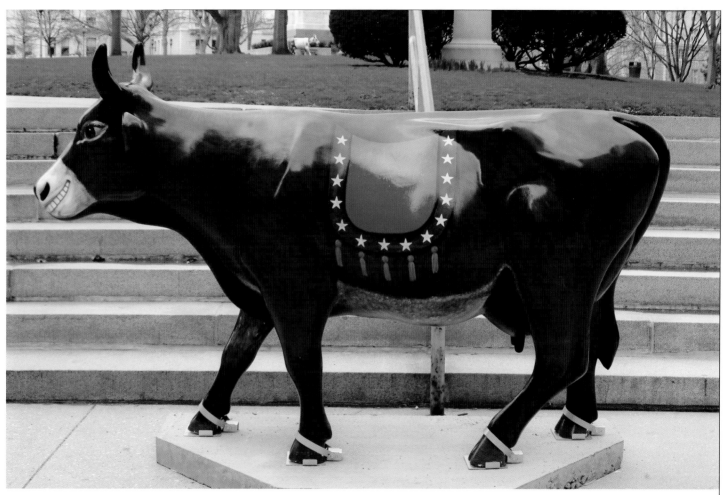

Politicow
Patricia Lambert Marshall
Pugliese Associates

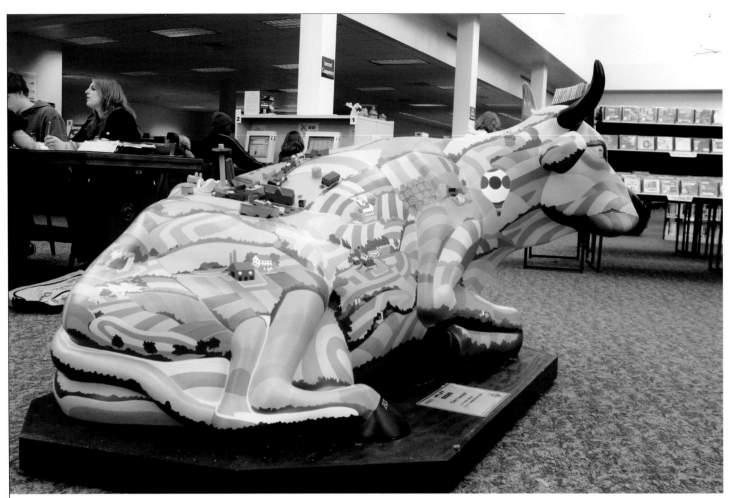

Dairy Township
Bruce Johnson
Township of Derry Industrial-Commercial Development Authority

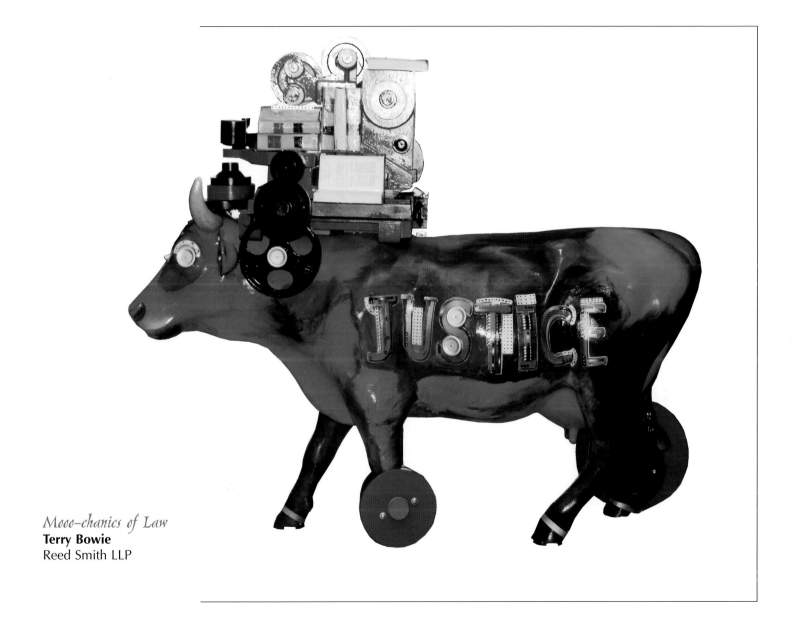

Mooo-chanics of Law
Terry Bowie
Reed Smith LLP

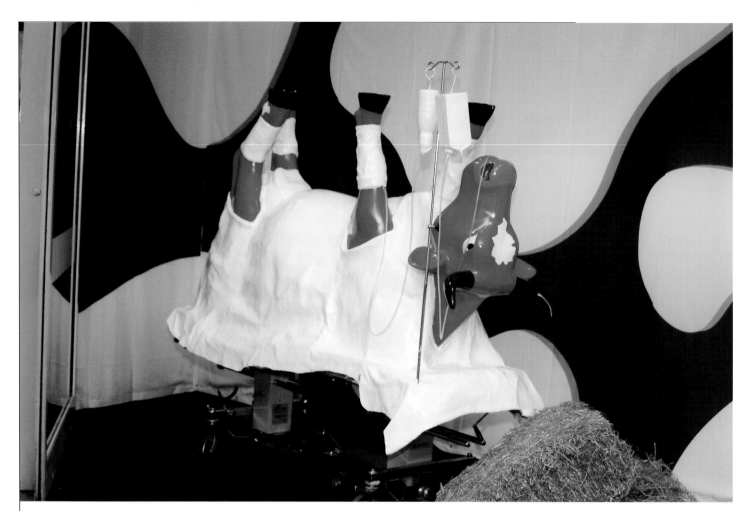

Guernsey on a Gurney
Bruce Johnson and Paul Nagle
Triad Strategies, LLC

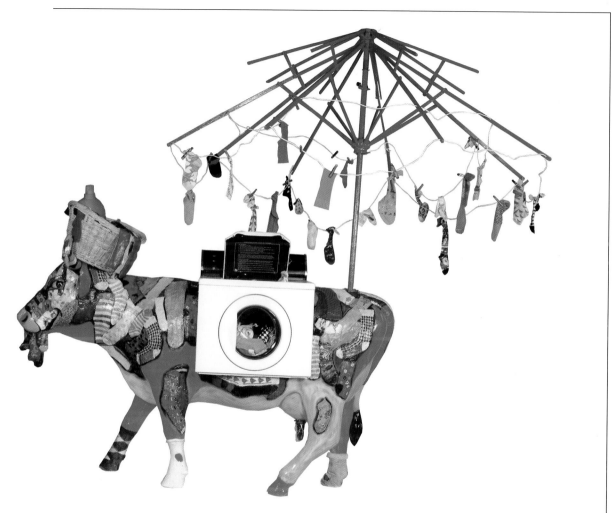

Got Socks?
The Harrisburg Academy Family
Shumaker Williams, P.C. for the Harrisburg Academy

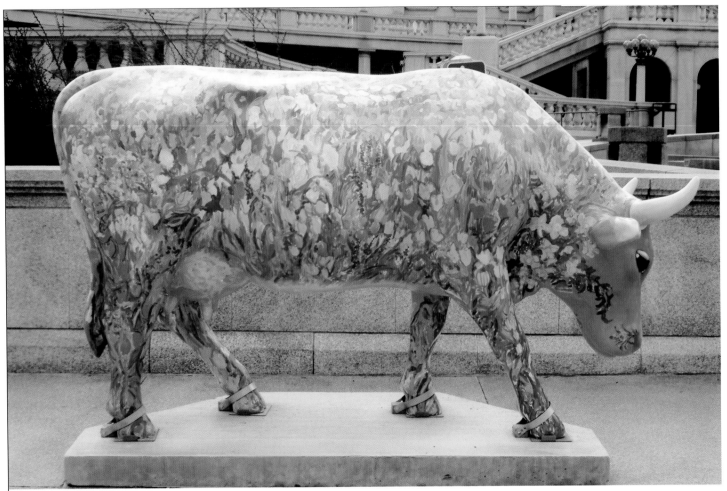

Posie
Michele Taylor
Webber Associates

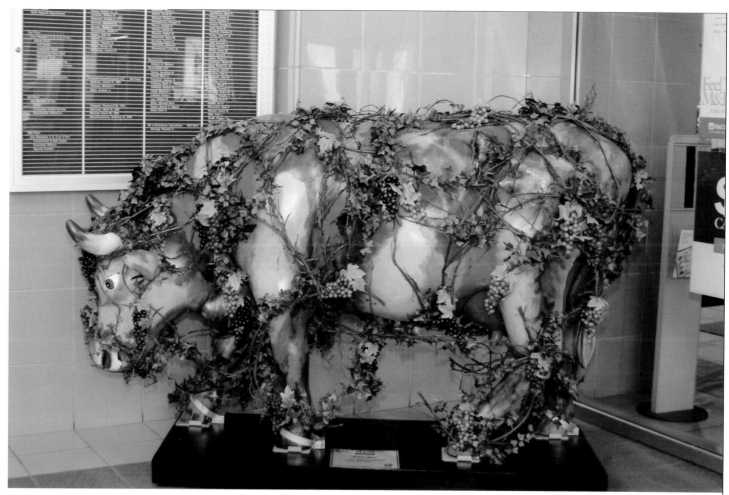

Beaux Wine
Stephen F. Krempasky
M&T Bank

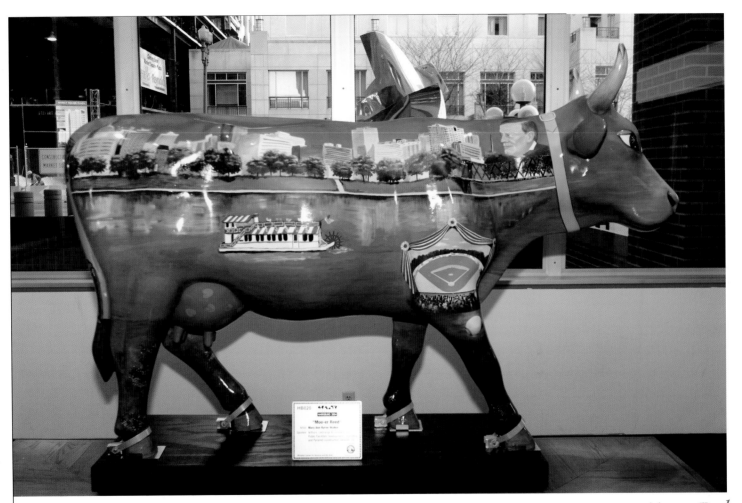

Moo-er Reed
Mary Ann Byrne-Walker
Arthurs Lestrange & Company, Inc., Public Facilities Development Corporation,
and Pyramid Construction Services, Inc.

Artist Index

Sponsor Index